A HISTORY OF

SMUGGLING

IN FLORIDA

DATE DUE

GAYLORD			PRINTED IN U.S.A.

D1598618

A HISTORY OF
SMUGGLING
IN FLORIDA

RUMRUNNERS AND
COCAINE COWBOYS

STAN ZIMMERMAN

Charleston · London

THE
History
PRESS

Published by The History Press
Charleston, SC 29403
www.historypress.net

Copyright © 2006 by Stan Zimmerman
All rights reserved

Cover art by Deborah Silliman Wolfe.

First published 2006
Second printing 2008

Manufactured in the United Kingdom

ISBN 978.1.59629.199.7

Library of Congress Cataloging-in-Publication Data

Zimmerman, Stan.
 A history of smuggling in Florida : rum runners and cocaine cowboys / Stan
Zimmerman.
 p. cm.
 Includes bibliographical references and index.
 ISBN-13: 978-1-59629-199-7 (alk. paper)
 ISBN-10: 1-59629-199-0 (alk. paper)
 1. Smuggling--Florida--History. I. Title.
 HJ6690.Z56 2006
 364.1'33--dc22
 2006026777

CONTENTS

PREFACE

Florida's unique location, peninsular geography, poverty of natural resources and history of hustle produced this chronicle of illicit activity. Smuggling is a constant but unrecognized factor in Florida's steamy history. The navigator who found Florida was first a smuggler. Today's Florida governor is married to a smuggler of clothing and jewelry. Not to mention a previous governor who was a gunrunner.

It is a wild tale. A story of unconquered Native Americans. A story of the richest men in the world. A story of mud towns that became metropolises. A story of heroes and villains.

On one hand, we have desires; on the other hand, suppliers. And in between, stern government regulations. Nobody knows how many things are illegal to import. This bottle of rum is OK but that one is not. This jar of caviar is fine but next week it's totally forbidden. The rules change daily. One aspect is constant: demand for contraband is strong and growing. Always has been, probably always will be.

Because smuggling is a covert activity, documentation is impossible to find until a smuggler is caught and indicted. Only then are records available, although what is made public is carefully sanitized. Because so many smugglers are never caught, the scope of their operations is nearly impossible to quantify.

Today's official guesstimates are staggering. The Federal Drug Enforcement Administration gives an annual range—for illegal drugs only—of $13.6 to $48.4 billion in 2005. The Federal Reserve Bank of Boston estimated in 2001 that $30 billion in illegal profits were laundered that year in the United States. The big number—total annual money laundering worldwide in 2001—was estimated between $600 billion and $1.5 trillion. While those sums are profits from all illegal industries, most of them depend on smuggling.

Florida's fraction of both the national and global totals is unknown. But we know virtually everything worth smuggling has—at some point in time—passed quietly across Florida's borders, often by the ton.

My aim is neither to glorify nor vilify. My aim is to display a fundamental truth about Florida: it is a smuggler's paradise. Smugglers developed Florida as we know it today and they are shaping its future for tomorrow. From the Governor's Mansion to your next-door neighbor—howdy, smuggler!

ONE

EVERYBODY'S A SMUGGLER

It was the wee hours of a February morning. I was aboard the Sibelius Express between Moscow and Helsinki. The Berlin Wall was down, the Soviet Union collapsed and a shaky new Russia was rising from the wreckage. Winter snow covered the poplars streaming outside the window of my train compartment.

Suddenly there was banging on the door. "Customs! Passports!" The door slid open as I tumbled in my underwear from my sleeper. I was confronted with one of the ugliest women I've ever seen. She looked like a toad dressed in a heavy wool uniform. "Passport!" she croaked.

I started to put on my trousers, but "Niet!" was her response, so instead I extracted my passport from my bag and handed it to her. We stood in silence while she flipped the pages, and then examined my hard-won visa on a separate sheet of paper. It had taken years to arrange that visa; its sponsor was the new Russian Ministry of Defense, for I was in the new Russia to interview ex-Soviet submarine designers.

That didn't cut any mustard with my early hours visitor. "Declaration?!" she nearly shouted. "No," said I. "Nothing to declare." She spun and motioned to four men in the carriage hallway. They entered the compartment—it was getting crowded now—and proceeded to take it apart. The ceiling came down, the seats and bed were disassembled: it was a practiced deconstruction, completed in only a few moments.

Toad lady surveyed the wreckage and then motioned for me to open my bag. I pulled down the zipper, and her eyes lit on a small oil painting I'd purchased in St. Petersburg. "Forbidden to export art from Russia!" she said, as she lifted it between thumb and forefinger. Her bully-boys then attacked the bag with a vengeance, uncovering my other prize—a catalog in French from the Pushkin in Moscow, the museum where all the impressionist paintings expropriated during the Russian Revolution ended up.

I purchased my small oil painting in a freezing rain outside the Hermitage museum in St. Petersburg for a pittance. I even asked for a receipt, a scrap of paper with a scrawl I couldn't read. Later I saw the exact same painting, in larger and smaller sizes, all over St. Petersburg. But I didn't mind, I still enjoyed my little seascape.

By now the compartment was chaos: my dirty clothes mingling with parts of the ceiling, my reporter's notes fallen into the disemboweled bed, my shoes dangling from the luggage rack and my painting still between the thumb and forefinger of the toad woman.

She looked at the Pushkin catalog and then at my wee painting. I produced the receipt. She examined it carefully. She put the painting down and thumbed through the catalog. "Art is good," she said, and walked out. I scurried to repack my belongings as the bully-boys rebuilt the compartment. Then they too were gone.

I waited for the cops to arrive and haul me away, but they never came. I arrived in Helsinki, painting intact, with the internal glow of a successful smuggler.

The Sibelius Express was not my introduction to smuggling. As a reporter, I served an apprenticeship in Florida and spent journeyman time here as well. Smuggling stories were at times an almost daily occurrence. As a broadcaster, I covered the transition from marijuana to cocaine. As a sailor in the Ten Thousand Islands of Florida, south of Naples, I observed the low-flying DC-3s bearing illicit cargoes over the Everglades en route to landings on the deserted streets of undeveloped proto-cities like North Port and Cape Coral.

On one trip, I witnessed the nighttime passage of an unlit ship reeking of human stench as it passed within a stone's throw of my anchorage. It was an odorous reminder of slave ships in centuries past. Other times, I've seen bales of marijuana bobbing like sea turtles in the Gulf of Mexico, jettisoned or lost overboard by midnight pot haulers. Yes, I've been close to smuggling.

As a reporter, I covered trials of major cocaine smugglers, senior law enforcement officers and even a sheriff caught in the coils of smuggling. And years later, my community became involved in the story of a single orchid, smuggled out of Peru and ending up in a botanic garden that pled guilty to the federal crime of possessing a protected species. A friend is still in prison for selling Cuban cigars to the cognoscenti of Longboat Key.

Smuggling is a very old and very profitable profession in Florida. While few talk about it openly, there is every reason to believe it is the largest industry in the state. And probably has been for decades, maybe centuries. Because of the state's peninsular geography, smuggling may always be a major component of Florida's economy.

Floridians want to believe the state's largest industry is tourism, and indeed, millions of people come here every year and spend billions to enjoy themselves. Some of them linger to buy real estate, the state's second largest legal industry. It is an old tradition, selling swampland to Yankees. But the Yankees may not realize that the land they are buying might—at some point—have been involved in a smuggler's scheme to launder profits. In the twentieth and twenty-first centuries, the relationship between real estate and smuggling is profound.

The history of smuggling in Florida is the history of Florida. Smuggling has done more to incubate the development of the peninsula than any legislation. Smuggling is a recurring theme, for something is always being smuggled in Florida.

Smuggling is the economic crime of possession and transport of illicit materials across national borders. Today there are a myriad of different items you cannot bring into the United States. If you do, you can go to jail. Some of these items depend on their origin. For example, cigars are legal unless they are made in Cuba.

Smuggling can involve a single flower. Or it can be an industrial enterprise, such as tons of guns and ammunition. Regardless of scale, it demands an eager buyer, because smugglers don't keep inventories. The sooner the "hot goods" are unloaded and sold, the happier the smuggler is.

Smuggling almost always requires an avid resale market. Whether it's bootleg rum or Colombian cocaine, a wholesaler requires retailers. The price markup is drastically higher than normal retail, which is why the trade in smuggled goods is so lucrative. Smuggling is a very pure form of entrepreneurial capitalism. By definition, smuggling evades government regulation.

Smuggling has a romantic side. Jimmy Buffett's smuggler anthem "Havana Daydreamin'" ("waitin' for some mystery man to pay him for his time…") resonates with anybody who's smoked a joint, snorted a line, preheated a Cohiba or moved a "forbidden" piece of Russian art. The dashing Rhett Butler in *Gone With the Wind* was a smuggler.

History is replete with good-guy smugglers. William McCoy comes to mind, as do the skippers of U.S. Navy ships who picked up contrabands. Totch Brown and Junior Guthrie are icons for this kind of thinking. You'll read about them all and more like them.

Smuggling also has a grim side. There is slavery and murder in these pages, spread over centuries, including our own. Because smugglers live beyond the law, there is treachery, double-dealing and cruel revenge.

Florida's history of smuggling parallels and amplifies the official history of the state. Even before its "discovery," there was smuggling in Florida. The tale begins with slavery, a practice continuing to this day.

STRANGERS IN A STRANGE LAND

FICTION

Juan Ortiz surveyed the low coastline beyond the port bow from the helm of a three-masted caravel. Twelve other men stood ready at the sails and anchor. The waters of what would be called Biscayne Bay were cloudy as the tannin-laced runoff from the mangrove fringe intermixed with the crystalline bay. Ortiz searched for a break in the twisted fortress of mangrove, a hint of solid ground that would lead to the interior and the prizes he sought.

Ortiz was on the cutting edge of the enormous surprise delivered to the Spanish crown by Columbus and his followers. Not yet a decade had passed between Columbus's first voyage and Ortiz's foray to what we know as Florida. While Columbus found glory and immortality, Ortiz was seeking a more tangible reward—slaves.

The wall of green and brown showed a momentary interruption of blue-green, revealing the mouth of a river or large stream. Ortiz ordered the sails struck. As the caravel coasted to a stop, he ordered the anchor dropped. Without a further word, the sailors unshipped and lowered a longboat into the calm water.

The men immediately switched roles from sailors to soldiers. From the caravel's hold, they passed up their meager inventory of armor, swords, pikes and a pair of arquebuses. Slow-match fuses were lit with flint and steel, and six men plus Ortiz carefully climbed into the longboat. The remaining crew handed down heavy bags, before settling in to guard the ship in their absence.

The whirlwind Spanish conquest of Cuba presented an unprecedented problem. Great labor was required to exploit the new possession, but few Spaniards were willing to do the work. Nearly every Spaniard dreamed of seizing wealth in the New World and had little desire to hew stones, build forts or till fields.

The indigenous peoples were enslaved quickly by the Spanish with their steel weapons, horses and war dogs. The Indians were defenseless against infectious diseases introduced by the Spanish and died in droves. With their hunter-fisher-gatherer economies destroyed, malnutrition and cultural dislocation further undermined their stamina. The Spanish demanded more and more slaves, opening opportunities for adventurous men like Juan Ortiz.

As the crew rowed for shore, Ortiz was alert for ambush. He knew he wasn't the only slaver working this coast. The easiest and largest captures were made from villages that had never seen a Spaniard. But a few Indians always escaped to spread the word of a new predator who came from the sea and devoured entire families, taking them away never to be seen again.

Slowly the river mouth opened. Ortiz recognized the area would be ideal for a settlement, with dry land visible on one side and easy access to fishing in the bay. The crew remained quiet, carefully tending their oars to prevent unnecessary noise. Birds flitted overhead, including the occasional scarlet flash of a cardinal.

As the river's course turned south, a village was revealed. Peaked roofs thatched with palmetto fronds rose above pilings sunk at the river's edge. Dugout canoes were beached underneath. A thin tendril of smoke rose almost straight up into the bright midday sky of April 4, 1498.

A sudden shout pierced the air. The Spanish were spotted. Ortiz steered directly for the huts and urged his men to pull hard on their oars. The longboat sped over the water. Ashore, the noise grew louder, as women grabbed children and cried their alarm. Clearly they feared the men with the shiny hats.

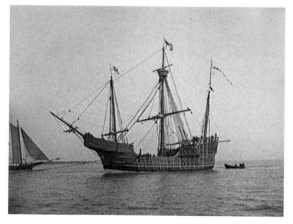

This Spanish recreation of a caravel (supposedly Columbus's *Santa Maria*) was built in the late nineteenth century. It was sailed to the United States for display at either the World's Columbian Exposition or the Columbian Naval Review. It is representative of the ships discovering and exploiting the New World in the sixteenth century. Note the high "castles" fore and aft. *1893 photograph on glass by Edward H. Hart, Courtesy Library of Congress.*

The longboat scrunched on the sandy beach and the men stepped ashore. One arquebusier remained behind with the boat, while Ortiz and five other Spaniards walked slowly into the village. Children huddled behind their mothers, but no one ran for the palmetto scrub. Ortiz realized this village had never been raided before. Otherwise the Indians would have fled. Using the flat of his sword, he herded the villagers back toward the longboat.

The arquebusier opened one of the heavy bags and removed coffles to link the women together to prevent their escape. The men would return in a day or two and be captured as well. In the meantime, the Spanish would have their sport with the women. Ortiz estimated this raid would capture perhaps fifty slaves, and after a quick trip back to Havana, he would return to this coast in search of more.

FACT

Juan Ponce de León is credited with discovering Florida in 1513. Long before his voyage of discovery, the Spanish undoubtedly visited the peninsula in search of gold (there was none) and slaves (there were many). It is likely Ponce's legendary navigator knew much more about the waters around Florida than is acknowledged in the official history books. He certainly was a lucky man who "discovered" the nautical essentials required to travel from Cuba to both coasts of Florida and return. Ponce's "voyage of discovery" was very much a cakewalk.

Both Ponce and his navigator—Antón de Alaminos de Palos—accompanied Columbus on at least one of his voyages of discovery. It is likely they met on Columbus's second voyage (1493–1496), among the 1,200 people aboard seventeen ships. It was a very eventful trip.

On the first voyage, Columbus traveled through the modern Bahamas to reach the eastern side of Cuba and return via Hispaniola. On his second trip (with Ponce and Alaminos), Columbus sailed farther south, crossing through the Antilles to discover Puerto Rico, the southern shore of Cuba and Jamaica, before turning back to Hispaniola and eventually returning to Spain. On the trip, Columbus captured 1,400 slaves, bringing 300 back to Spain. But enslaving Indians was against royal policy and the Crown ordered them freed and returned to America.

The royal command was followed on Columbus's third voyage (1498–1500), but Spaniards in the New World continued to capture and use Native Americans as slaves. Columbus himself, in his logbook, noted the use of Indian slaves for sex. In 1501 slavery in the New World was made legal by royal decree.

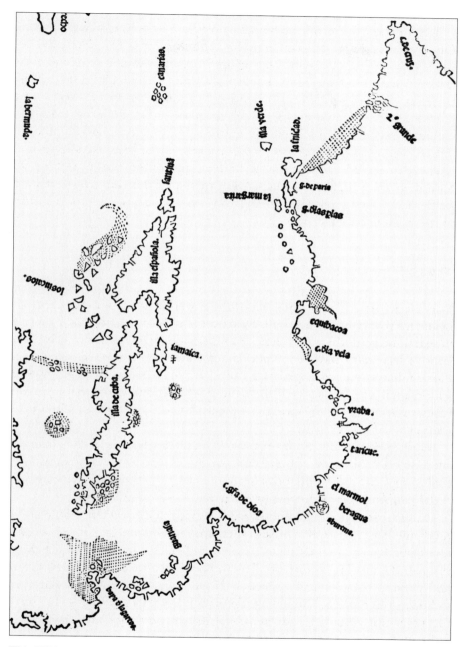

This 1511 map was drawn by Andrés de Morales two years before the "discovery" of Florida by Ponce de León. Both "illa de cuba" and "illa española" are easily recognized. North is to the left. Columbus explored Central America south of the Yucatán on his fourth and final voyage between 1502 and 1504. The map comes from Pietro Martire d'Anghiera's book *Impressum Hispali* published by Jacobum Corumberger in April 1511. *Courtesy of the John Work Garrett Library of the Johns Hopkins University.*

Ponce came back to the New World in 1506 at the age of forty-six to lead the conquest of Puerto Rico. He was appointed governor in 1509. For his work in the subjugation of the indigenous peoples and his early colonization efforts, Juan Ponce was commended by Charles V, King of Spain. While in Puerto Rico, Ponce heard rumors of a land north of Cuba called "Beimeni." The rumors were so persistent that "Beimeni" was mapped before it was "discovered."

An Italian priest in service to the Crown, Pietro Martire d'Anghiera, included it on his 1511 book. He labeled a landmass north of Cuba as "Isla de beimeni parte." In 1512 Ponce petitioned the Crown to seek this mysterious land. Charles agreed.

Ponce returned to Puerto Rico and arranged his expedition. A key participant was Alaminos, about whose activities between 1496 and 1513 we know little or nothing. We do know on March 3, 1513, he left Puerto Rico with Ponce and three ships to set sail into the history books.

Alaminos guided the expedition's three ships east of the treacherous Bahamian waters to arrive offshore of Florida on March 27. This was either good luck or the first indication of Alaminos's prior knowledge of the area. Modern navigators using current charts think of this route as an easy, full-sail passage to Florida.

It is important to remember the nature of the ships sailed by the Spanish nearly five centuries ago. They were designed for medieval-style naval warfare, with high "castles" fore and aft so soldiers could enjoy "high ground" while fighting against boarders. The cannon-against-cannon style of naval warfare was a century in the future. The ships also carried at least eight feet of draft, making exploration close to an unknown shore very risky. Once aground, the wooden ships were fragile and their loss would strand the crew on a hostile shore far from home.

Alaminos's second bit of good luck occurred near Lake Worth inlet (modern Palm Beach) where the expedition encountered the effects of the furious Gulf Stream. As Ponce records, even with full sails, his ships were swept backward by the current. Ponce called the area Cabo de Corrientes, the Cape of Currents, although we know now it is not a cape. Alaminos defeated the Gulf Stream with a counterintuitive strategy by sailing very close to shore, an always risky tactic with fragile, deep-draft vessels.

The effects of currents on ships are almost impossible to calculate when a ship is beyond the sight of land. Without a point of reference, the ship can seem to be moving ahead (sails pulling, bow wave splashing) while in reality it is stopped or even moving backward. Alaminos's "discovery" of the Gulf Stream and then a tactic to defeat it is either the mark of a fine navigator or a man with prior experience.

Alaminos's finding was important, because it opened the door to two-way trips between Cuba and Florida. If Spanish ships could not sail against the current, any trip north from Havana would be one-way—to Spain. By sailing close inshore, Alaminos either pioneered the route south or was following a well-worn path forged by Spanish slavers over the previous decade. As Alaminos was an "old salt" in American waters by this time, it is likely he knew of this trick, either from slavers or from his own slaving voyages.

The expedition continued south. Ponce went ashore on several occasions and was often met with hostile Indians. This is another argument that Native Americans had reason to suspect the motives of the men from the sea. Surprisingly, one captured Indian understood some Spanish, according to a written account of the voyage by Antonio de Herrera. And that, of course, appears to be conclusive proof that Ponce was not the first Spaniard to reach Florida.

Alaminos's exceptional luck continued as the expedition resumed its southward and then southwestward voyage. To this day, coral heads rise up suddenly to rip the hull of unwary sailors in the Florida Keys. On Pietro Martire's map, the Florida Keys are clearly visible. But Alaminos stayed away from them, sailing past Key West and the Marquesas before turning north through the Rebecca Shoals passage to search for the southwestern coast of the peninsula.

D'Anghiera's dots and small circles north of Cuba foreshadow the discovery of the reefs, shallows and islands of the Florida Keys and Dry Tortugas. These few lines of ancient ink seem to indicate knowledge of Florida before the arrival of Ponce two years later. *Courtesy of the John Work Garrett Library of the Johns Hopkins University.*

17

The Spanish later named the Florida Keys "the Martyrs" because so many ships were wrecked on the reefs lying offshore of the islands. Perhaps Alaminos already knew of "the Martyrs" and the Rebecca Shoals passage, or maybe his good luck and sharp senses were responsible for his cautious route.

Alaminos took the intact fleet all the way to San Carlos Bay near Sanibel Island, where he and Ponce found what they thought was a sheltered anchorage. They were attacked there by Calusa Indians in canoes and catamarans made from dugouts. One European was killed and Ponce named the island "Matanzas," meaning "slaughter." After nine days, they hauled anchor and turned south to return to Puerto Rico, but not before Alaminos also "discovered" the Dry Tortugas.

This was a remarkable voyage. Florida is very low-lying, especially its Keys and barrier islands. For Alaminos to guide three deep-draft, cranky-sailing wooden ships for six months through a myriad of uncharted dangers without loss is exceptional navigation. Ponce and Alaminos not only "discovered" Florida, but also the Keys with their deadly reefs, the Rebecca Shoals passage, the San Carlos anchorage and the Dry Tortugas. Quite a feat, unless Alaminos (and perhaps Ponce too) were privy to the "local knowledge" earned by earlier slaving expeditions to Florida.

After return to Spain to present his discoveries, Ponce was assigned the chore of pacifying the cannibal Carib Indians in the Caribbean. He would not return to Florida for seven years.

In 1517, Alaminos navigated another expedition, discovering the Yucatán peninsula of Mexico. It has been suggested this voyage was a slaving expedition, although others doubt it. In any case, the Spaniards received another "hot reception," this time from the Mayans. After a short military engagement, the Spanish withdrew and sailed along the coast looking for fresh water but were confronted by hostiles at every stop. They did, however, glimpse the gold of Central America.

In desperation, Alaminos sailed from the Yucatán back to San Carlos Bay near Sanibel, where the Calusa attacked again. During a skirmish while filling water casks ashore, Alaminos was wounded in the neck by an arrow but survived. The expedition returned to Havana.

The New World was full of such adventuresome young men. Hernán Cortés arrived in 1503 at the age of eighteen. In 1519 Cortés landed in modern-day Veracruz, burnt all of his ships—except the one commanded by Alaminos—and went forward to topple the Aztec empire. Later that year Cortés packed the looted Aztec booty and loaded it aboard the first treasure fleet to Spain. It was commanded by Alaminos, who rode the mighty Gulf Stream two-thirds of the distance to Europe. Alaminos then disappears from the pages of history after a quarter-century of New World navigation.

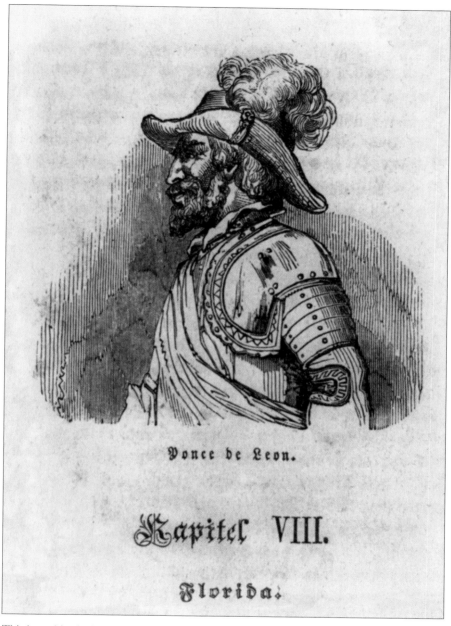

Ponce de Leon.

Kapitel VIII.

Florida.

This is a whimsical woodcut of Ponce de Léon made centuries after his death. The legend of his search for a youth-giving fountain spread far beyond his credit as Florida's discoverer and lures people to the Sunshine State even today. There are at least three "fountains" in the state claiming to offer Ponce's elixir of everlasting life, all of them far from his real route of travel. *Courtesy Library of Congress.*

When Columbus first confronted the indigenous peoples of the Caribbean, he reported their peaceful nature. Three decades later, the Spanish faced hostility everywhere they landed. It is likely the real "discovery" of the Gulf of Mexico littoral—including Florida—was conducted by Spanish slave-collecting expeditions in violation of Spanish royal policy. The smuggling of Indian slaves was Florida's first industry and Antón de Alaminos was almost certainly one of its pioneers.

THE CUBAN CONNECTION

With slavery legalized in both the Spanish and British colonies, the legitimacy of trafficking in human beings eliminated the need to smuggle them. More than 250 years later, after the American Revolution, opinions about the morality of slavery were divided. In one of the many compromises that resulted in the U.S. Constitution in 1787, the importation of slaves was allowed until 1808. On January 1 of that year—after three centuries—the import of slaves into the United States became illegal. Making importation illegal, of course, created a smuggler's market for slaves.

Anthony Pizzo, in his genealogy-filled book *Tampa Town 1824–1886*, writes of an expatriate Frenchman who came to Florida and became a mighty entrepreneur and occasional smuggler. Count Odet Phillippe, a great-nephew of King Louis XIV, arrived in Tampa in 1823 as a refugee. "In Tampa, he built houses, opened a billiard hall, ran a bowling alley and an oyster shop and did a brisk trade in cattle, horses and hogs. He bought and sold slaves, probably smuggling them in from Cuba, and shipping them north in long chained coffles for the markets of Georgia, as overseas and overland smuggling became an important trade after the United States put the Embargo on foreign slave trading," Pizzo wrote.

Britain abolished the slave trade in 1807 and fined British captains £100 for each slave they were transporting. The Royal Navy began an aggressive naval campaign to apprehend slaving ships at sea. To avoid the fine, slavers would toss their cargo into the sea if they risked capture by the Royal Navy, creating lethal consequences for the British policy. Slavery itself was abolished by Parliament throughout the British Empire in 1833, but slaves continued to be smuggled into Florida until the outbreak of the Civil War.

The capture of the bark *Wildfire* in 1860 provides an insight into the industry. It was built in 1852 as part of the great wave of shipbuilding created by the California gold rush. Although a "clipper" in design, *Wildfire* carried square sails only on the first two masts and was thus categorized as a "bark." It was fast and went into Mediterranean service (where it set a speed

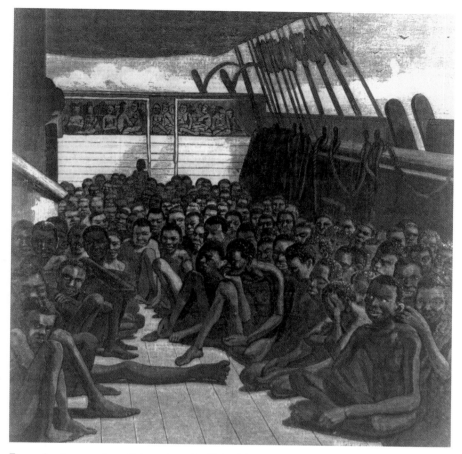

Even after importation of slaves into the United States was abolished in 1808, the trafficking in human beings did not stop. The *Wildfire* was captured by the U.S. Navy in 1860, probably bound for Cuba. This image of the freed slaves still aboard in Key West harbor gives an idea of the crowding aboard slavers. Several modern artists used this engraving as a model to demonstrate the horrors of the slave trade. *Engraving from* Harper's Weekly, *June 2, 1860. Courtesy the Library of Congress.*

record for the crossing to Gibraltar from Boston). *Wildfire* was later put in service on the New York–Veracruz, Mexico run.

The American shipping industry overbuilt for the gold rush, and soon shipping rates plummeted, as did the cost of used cargo vessels. In 1859, *Wildfire* was purchased by Pierre Lepage Pearce. The sugar industry in Cuba at the time was in a state of expansion. Sugar prices were high and slaves were in short supply. The British antislavery patrols were putting a crimp in distribution from West Africa, so the trade was even more lucrative. The combination of circumstances—high demand, restricted supply, cheap

transport and government prohibition—was perfect for smuggling. Pearce put his fast-but-inexpensive bark to work as a slaver. *Wildfire* picked up 615 Africans near the Congo River and sailed for Havana.

Wildfire was intercepted on April 26, 1860, by the U.S. Navy steamer *Mohawk*. The crew was arrested, and *Wildfire* was sailed to Key West, arriving in early May. Only 507 Africans survived the trip. The ship was condemned and sold for $6,500. The ship's captain—Phillip Stanhope—and crew were charged, but a Key West grand jury failed to indict them and they walked away.

Wildfire was not the only slaver captured that spring. On May 12, the bark *William* was towed into Key West with 513 Africans aboard (of the original "cargo" of 744), and the bark *Bogata* was sailed into Key West on May 25, 1860, with 411 Africans aboard. The captains and crews were arrested but never found guilty.

Thus in one month, the U.S. Navy brought three slavers into Key West carrying more than 1,400 enslaved Africans. While purely a coincidence, it is interesting to note the number is the same as the number of enslaved Native Americans Columbus captured on his third voyage, more than three centuries earlier. Slavery was abolished in Cuba in 1888. Ten years later, Spain lost Cuba in the Spanish-American War.

SMUGGLING FOR FREEDOM

A kind of "reverse smuggling" occurred during the Civil War, as escaped slaves attempted to find freedom. Early in the war, a group of escaped slaves appeared at Fort Monroe, Virginia, and the commander admitted them. When the slave owner appeared and demanded their return under the Fugitive Slave Act, he was told the secession of Virginia meant Federal law no longer applied in the Confederacy.

The fort's commander, Benjamin Butler, reported to the secretary of war on July 30, 1861, and referred to the escaped slaves as "contraband of war." The name stuck. Although the "Contraband Doctrine" was never officially adopted, the idea and the term became widely applied. During the Civil War, nearly a quarter-million escaped slaves worked for the Federal government.

Not all the slaves escaped on foot. Some "contrabands" sailed patchwork boats out from the coastline in search of blockading Federal vessels. The Union navy secretary gave instructions to his captains to accept these self-smugglers, and if possible put them to work.

This was printed December 14, 1861 in *Harper's Weekly*: "We give the following extracts from the Report of the Secretary of the Navy:"

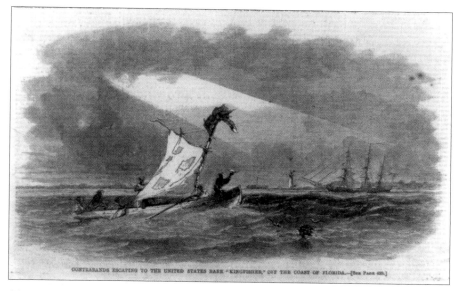

CONTRABANDS ESCAPING TO THE UNITED STATES BARK "KINGFISHER," OFF THE COAST OF FLORIDA.—[SEE PAGE 488.]

After the Union imposed a blockade against the Confederacy, escaped slaves took to the sea in makeshift craft in search of freedom. This wood engraving foreshadows the Cuban "rafters" more than a century later who risked their lives in crude contraptions in search of liberty. U.S. armed forces also rescued thousands of them. *Wood engraving from* Harper's Weekly, *June 12, 1862. Courtesy Library of Congress.*

EMPLOYMENT OF FUGITIVES.

In the coastwise and blockading duties of the navy it has been not unfrequent that fugitives from insurrectionary places have sought our ships for refuge and protection, and our naval commanders have applied to me for instruction as to the proper disposition which should be made of such refugees. My answer has been that, if insurgents, they should be handed over to the custody of the Government; but if, on the contrary, they were free from any voluntary participation in the rebellion and sought the shelter and protection of our flag, then they should be cared for and employed in some useful manner and might be enlisted to serve on our public vessels or in our Navy-yards, receiving wages for their labor. If such employment could not be furnished to all by the navy, they might be referred to the army, and if no employment could be found for them in the public service they should be allowed to proceed freely and peaceably without restraint to seek a livelihood in any loyal portion of the country. This I have considered to be the whole required duty, in the premises, of our naval officers.

An illustration in a later edition of the magazine gives an impression of the courage required to be a "contraband" at sea and foreshadows experiences a century later as others took to the seas in homemade boats bound for Florida in the attempt to smuggle themselves to freedom.

THE $12 BILLION RACKET

The American Civil War put an end to slavery in the United States. In 1880 most immigration restrictions were eliminated. Millions of people from all over the world came to the United States legally. With immigration open, no profitable reason existed to smuggle humans into Florida. But with the reintroduction of immigration restrictions in 1921, the smuggling of people would reappear in what authorities today call "human trafficking" and "alien smuggling." Today it is a major industry and Florida is a full participant.

"I would like to begin by providing an important clarification and necessary distinction between the terms alien smuggling and human trafficking," testified Charles Demore, interim assistant director of investigations, Department for Homeland Security on July 25, 2003, before a U.S. Senate committee. "Alien smuggling and human trafficking, while sharing certain elements and attributes and overlapping in some cases, are distinctively different offenses. Human trafficking—specifically what U.S. law defines as 'severe forms of trafficking in persons'—involves (unless the victims are minors trafficked into sexual exploitation) force, fraud or coercion and occurs for the purpose of forced labor or commercial sexual exploitation.

"Alien smuggling is an enterprise that produces short-term profits resulting from one-time fees paid by or on the behalf of migrants smuggled," Demore told Congress. "Trafficking enterprises rely on forced labor or commercial sexual exploitation of the victim to produce profits over the long-term and the short-term," he said. "Human smuggling has become a lucrative international criminal enterprise and continues to grow in the United States. This trade generates an enormous amount of money—globally, an estimated $9.5 billion per year."

Demore's estimate of the global market in human smuggling was topped by an intelligence estimate created in 2001 but not declassified until 2005. National Intelligence Estimate 2002-02D was the result of an examination of the problem by all United States intelligence agencies—military and civilian. It said, "Alien smuggling is now a $10 billion to $12 billion-a-year growth industry for migrant-smuggling groups that entails the transport

of more than 50 percent of illegal immigrants globally, often with the help of corrupt government officials, according to International Labor Organization (ILO) and other estimates."

FEET DRY, BACKS WET

True to its history, today's Florida fully participates in the smuggling of humans. It should be no surprise that the largest number of aliens being smuggled into Florida today are Cuban. The primary reason is a change in immigration law. Come-as-you-are Cuban immigrants long enjoyed a unique status under American law and were granted immediate asylum whether apprehended at sea or on shore. Hundreds of thousands of Cubans fled the island after the 1959 revolution; over a decade, the entire demographic of Miami changed. But blanket asylum was changed by the Clinton administration in 1995 to a "foot-wet, foot-dry" policy.

Cuban immigrants apprehended ashore still enjoy asylum, but if captured before reaching shore they will be repatriated back to Cuba. The new policy is part of an agreement brokered between the United States and Cuba to control illegal departures. Any Cuban "rafter" picked up in the straits of Florida now goes back to Cuba.

The legal change opened up an entirely new venue for professional smugglers, as Mireya Navarro reported on December 29, 1998, in the *New York Times*:

> *Federal officials said some of the alien smugglers, who sometimes also use the Bahamas by having their human cargo dropped off there by larger boats for pickup by a speedboat, use drug trafficking methods because they often smuggle drugs too. Of 21 pending federal prosecutions of alien smugglers in South Florida,* [Border Patrol Spokesman Keith] *Roberts said, at least six cases involve defendants also connected to drug trafficking.*

Navarro wrote the illegal aliens each pay between $1,500 and $8,000 for the ninety-mile trip between Cuba and the Florida Keys. The ride can be perilous. In April 1998, a speedboat carrying twenty-one Cubans capsized and fourteen drowned.

Demore told Congress in 2003, "In December 2001, a capsized vessel was found in the Florida Straits, alleged to have been carrying 41 Cuban nationals, including women and children. All are believed to have perished at sea."

The U.S. Coast Guard has the primary responsibility of keeping the aliens' feet "wet," intercepting them before they reach shore. The pace can be frantic, as evidenced by the activity around Thanksgiving of 2004:

On November 19, the coast guard intercepted a thirty-two-foot speedboat about nine nautical miles south of Big Pine Key. Aboard were thirty-eight Cuban migrants; two smugglers were arrested. On November 30, a coast guard airplane spotted a twenty-three-foot boat. It was intercepted near the Marquesas, and eight Cubans were found aboard; one smuggler was arrested. On December 5, a coast guard cutter located a twenty-seven-foot boat sixteen nautical miles from Santa Clara, Cuba. The vessel was found to contain twenty-five Cuban nationals. Two men were arrested.

The total in fewer than three weeks was seventy-four illegal migrants and five people arrested. While the financial gain isn't in the same league as cocaine, the human smugglers are still making big money. To use the preceding example, if the seventy-four people being smuggled each paid $5,000, that's a total sum of $370,000 for three trips between Cuba and the Florida Keys. Not bad money for less than one month's work.

OPERATION HONEYMOONERS

Call him "Mr. Lucky." Imagine being married seventeen times. In fact, Mr. Lucky had girls from several South American nations lined up to marry him, all so they could obtain a coveted green card from the U.S. government allowing the ladies to stay in the country permanently.

Mr. Lucky was part of a marriage fraud ring broken up by federal agents in 2005 following a two-year investigation. Thanks to a compliant employee at the Miami-Dade County Clerk's Office and several thousand dollars from each "fiancée," Mr. Lucky and others racked up roughly half a million dollars in profits. Thirty U.S. citizens were involved in 102 bogus marriages.

The easiest way for an alien to obtain a green card is marriage to a U.S. citizen. Immigration officials know that and regularly quiz the happy couple before bestowing their blessing (on the green card application). It's a tough interview, designed to weed out the imposters.

However, Mr. Lucky's gang knew that and took precautions. Elaborate weddings were videotaped, rice flying and glasses clinking. The ring (smuggling, not wedding) included notaries (who can perform marriages in Florida), brokers (to find just the right mate, nudge-nudge, wink-wink) and a very easygoing Miami-Dade County Clerk staffer who presided over the marriage license bureau (how convenient).

Vheadline.com, the Venezuelan electronic news service, reported ringleader Evelyn Ramos Cemprit worked with a paralegal—the marriage license bureaucrat—and thirty Americans willing to "get married." People from Venezuela, Peru, Colombia, Israel and Germany were victimized, paying $5,000 for the opportunity. Authorities said they would not be prosecuted but would be deported.

The penalty for aliens is immediate deportation and inability to obtain a green card in the future. U.S. citizens face five years in jail for willfully sidestepping immigration law.

The *St. Petersburg Times* reported on October 2, 2005, that the investigation began when an Immigration and Customs Enforcement agent noted one woman had been married seven times in two years. Once underway the inquiry was dubbed Operation Honeymooners. In 2005, 252,193 people received a green card after marriage to a U.S. citizen.

CRUISING TO AMERICA

Until immigration controls were tightened in the aftermath of the Al-Qaeda attacks in New York and Washington, a novel form of alien smuggling was practiced aboard Florida's ubiquitous cruise ships. It relied on what was called "en route processing." Thousands upon thousands of illegal aliens enjoyed a pleasure cruise from the Bahamas to Florida and an unfettered entrance into the United States.

For a trip from Fort Lauderdale to the Bahamas and back, an Immigration and Naturalization service inspector boarded the ship in Florida and stayed in a free stateroom. Upon arrival in Nassau, the inspector was free to shop and tour the city. Once embarked back to Florida, the ship broadcasted an announcement on the public address system asking all non-U.S. citizens to appear at the inspector's stateroom. The appearance was voluntary.

Once the ship returned to Fort Lauderdale, all the passengers disembarked without any further document checks. Thus any alien could board in Nassau, skip the voluntary document check en route and walk down the gangplank into the United States. The trick was getting aboard in Nassau.

Joel Brinkley reported in the *New York Times* on November 29, 1994, that the Immigration and Naturalization Service had no idea how many aliens entered the U.S. using the "en route processing" dodge. But an undercover study by the Border Patrol indicated thousands of people were smuggled into the country. Brinkley wrote:

The agency cannot say how widespread alien smuggling aboard the day-cruise ships really is or what nations most of the aliens come from. But a five-year undercover investigation by one of Mr. [Lloyd] Lofland's Border Patrol agents found that day cruises had become a favorite way for criminal organizations to smuggle aliens and drugs into the United States. In fact, the investigation, Operation Seacruise, showed that foreign criminal gangs used the cruises to smuggle their soldiers into the United States, where they sold drugs, smuggled weapons, committed 'homicides, assaults, drive by shootings, and other terror tactics,' a Border Patrol report said.

The scam was virtually foolproof. A ringleader in the Bahamas would offer to smuggle aliens into Florida for $1,000 each (or more). The ringleader would then telephone his partner in Florida and give a head count. An equal number of smugglers in Florida would buy tickets (often as cheap as $100) and use a voter registration card as proof of citizenship to board the cruise ship. At the time, no identification was required to register to vote and obtain the card.

In the Bahamas, passengers would be issued a boarding card permitting reentry to the ship. The smuggling chief would collect the boarding cards from his fellows and go ashore. The remainder of the smugglers would stay aboard. The boarding cards would be handed to the waiting aliens.

As the legitimate tourists thronged back to the ship, the aliens would mingle and show their boarding cards at the gangplank. Once aboard, they could ignore the "en route processing" and disembark in the United States unmolested. As the smugglers grew more confident of the route, they often told aliens to take a kilo of cocaine with them. The scam seemed foolproof.

Brinkley wrote that when the Justice Department questioned the practice of "en route processing," the Immigration and Naturalization Service defended it. "In a report issued last April [1994], the Justice Department Inspector General urged the immigration service to abandon en route inspections, calling them 'improper and inefficient.' The immigration service defended the practice, saying, 'The risk of illegal aliens entering the U.S. using cruise ships is low due to the quality of cruise-line personnel, the general type of vacationing passengers who routinely travel on cruises and the low frequency of detected illegal aliens.'"

After the 9/11 terrorist attacks, procedures were tightened up and now resemble the screenings routinely conducted at airports. The open door is now closed. But for decades, Florida's cruise ports were the site of frequent and flagrant immigrant smuggling.

T H E N E W S L A V E R Y

Florida is also in the thick of the new slavery: "human trafficking." These three cases were reported by the *Palm Beach Post* staff on December 7, 2003, in a special report titled "Modern Day Slavery." As revealed in this report, sometimes the trafficking concerns an individual slave:

> *Collier County sheriff's deputies answered a domestic abuse call at the house of Guatemala native Jose Tecum in Immokalee one night in November 1999. They found Maria Choz, 20, consumed by tears. She said Tecum was keeping her as a slave. Choz and Tecum were from the same area in Guatemala. Tecum had tried to buy her from her poor family, Choz told police. He eventually raped her and threatened to kill her or her father if she didn't come to Florida with him. Tecum made her live in the same house with his wife and children and forced her to have sex when his wife was not there. He found her work in the fields but took almost all the money she made. In 2000, Tecum was found guilty of involuntary servitude, kidnapping and smuggling and in 2001 was sentenced to nine years.*

And sometimes the crime is more systematic. Again, the *Palm Beach Post*:

> *In November 1997, two 15-year-old Mexican girls escaped a trailer near West Palm Beach and told authorities a brutal tale. They said they had been smuggled into the United States by a Mexican family and promised work in the health care industry. Instead, they were forced to become prostitutes, working in a string of trailers around south and central Florida—several in Palm Beach County—that catered to migrant workers. They were warned that if they tried to escape, their family members in Mexico would be harmed. They were told they had to work off $2,000 or more in smuggling fees. They were paid only about $3 per sexual encounter, minus extra debts such as medical expenses. At least two dozen other women worked in the brothels with them—some as young as 14. Prosecutors later said the people-smuggling and prostitution racket was run by Rogerio Cadena, originally of Veracruz, Mexico, and about seven family members. Prosecutors accused the Cadena family and its employees of brutalizing women—beating them, forcing them to have abortions, locking a rebellious girl in a closet for 15 days. In January 1999, Rogerio Cadena pleaded guilty, was sentenced to 15 years and forced to pay $1 million to the federal government.*

And sometimes there is no smuggling involved. The slaves are "recruited" locally. This story also is from the *Palm Beach Post*:

> *In April 1997, a team of St. Lucie County sheriff's deputies, on duty near Fort Pierce, was approached by George Williams, who said he'd just escaped from a house where he had been held against his will and beaten by a labor contractor named Michael Allen Lee. Williams and other men had been recruited from homeless shelters in central and southern Florida and forced to work picking crops for Lee. Prosecutors later said Lee often paid his workers in alcohol and drugs, including crack cocaine. He charged up to $40 a gallon for cheap wine. He beat them if they tried to leave. Williams and nine others filed a civil suit against Lee and his business associates, which was settled in January 1999 for an undisclosed amount. In December 2000, a federal grand jury indicted Lee on the criminal charge of servitude. He pleaded guilty, and in 2001 he and another defendant were sentenced to four years in prison.*

The enduring and pernicious nature of smuggling in Florida is demonstrated amply by its role in the centuries of slavery. Whenever slavery was illegal, smugglers supplied slaves. Their techniques foreshadow those used by untold generations of smugglers—the use of the sea as well as the role of Florida's island neighbors.

THE GUNS OF FLORIDA

A visit to Florida in the summer of 1565 by a pirate and smuggler determined the course of European civilization. The visitor was John Hawkins, later to become a famous British fighting admiral. He also was the first Florida arms smuggler, starting a legacy that lasts to this day.

Hawkins hated the Spanish for personal and religious reasons. As a trader, he repeatedly defied their authority by trading in the New World despite laws restricting commerce to Spanish merchants. In addition he also seized their ships, an act the Spanish considered piracy. Hawkins and other British pirate-traders brought badly needed supplies to various Spanish outposts in the Caribbean and Central America.

On his way home from such a voyage, Hawkins searched for a rumored colony along the Florida coast to replenish his supply of fresh water. While Florida was claimed by Spain, the first settlement on the peninsula was French. Protestant refugees from the religious wars in Europe had established Fort Caroline at the mouth of the St. Johns River in 1563 (east of present-day Jacksonville). It was the first European settlement in what would become the United States.

When Hawkins arrived at Fort Caroline on August 3, 1565, the French colonists were in desperate conditions. They had waited two years for resupply from France, their provisions were exhausted and the Native Americans grew tired of the novelty of feeding foreigners. The French were making preparations to abandon the colony and return home. The young colony had been struck by mutiny and hunger from the beginning. Some of the French Protestants had seized three of the colony's ships and sailed away from Fort Caroline to embark on a life of piracy against Catholic Spain.

News of this French settlement and its pirates soon reached Spain, which reacted with alarm. Spain's financial lifeline—the annual treasure fleet—sailed right by Fort Caroline, following the route pioneered by Alaminos along the Gulf Stream. A French pirate base on the peninsula was a dagger aimed at the Spanish financial jugular vein.

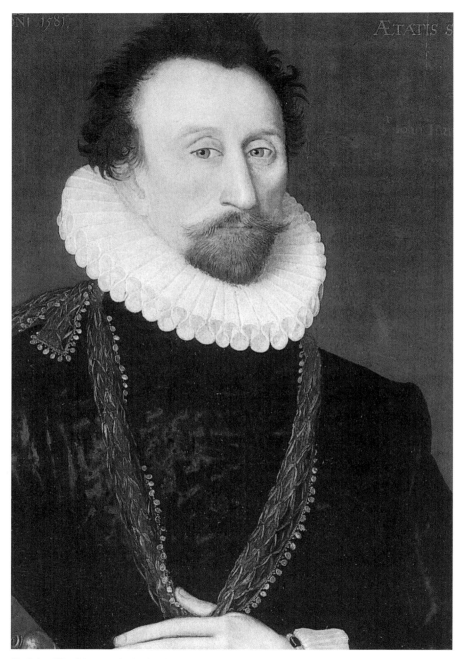

Sir John Hawkins revolutionized naval warfare after visiting Florida in 1565. He returned to England and designed warships capable of using cannon at sea effectively. Both a skilled sea captain and an accomplished bureaucrat, Hawkins rebuilt the British navy and was second-in-command when it defeated the Spanish Armada in 1588. *Courtesy National Maritime Museum, Greenwich, UK.*

The Spanish King, Philip II, contracted with Pedro Menéndez de Avilés to destroy the French settlement and establish a Spanish colony on the Florida peninsula. On June 27, Menéndez left Cadiz with ten ships, three hundred battle-hardened soldiers and his colonists.

Meanwhile the French King, Charles IX, authorized five hundred soldiers and two hundred cannons to reinforce Fort Caroline. The fleet left Dieppe on May 26 but didn't get far as a storm forced it to seek shelter at the Isle of Wight. It would take them more than three months to arrive in Florida.

Hawkins could not know he was sailing into a battle zone. And the Protestants at Fort Caroline could not know a relief expedition was heading their way. So on that lazy summer day in early August, John Hawkins anchored offshore of the French colony and went to visit.

Several of the French pirates had returned the previous May, making food shortages more acute. Hawkins made a fateful deal—French cannon for British food—and became Florida's first arms smuggler. Always interested in seizing Spanish ships, Hawkins undoubtedly talked with the French pirates. As sailors will, they talked shop, including Spanish tactics, armaments and the sailing characteristics of different vessels.

Spanish caravels of 1565 differed little from the ships sailed by Columbus in 1492. They featured three or four masts, with high "castles" fore and aft. Spanish naval tactics were still based on the experience of fighting Muslims and Turks in the Mediterranean. The decisive weapon was the sword, as ship-borne soldiers boarded enemy vessels. Defenders could retreat to the high castles fore and aft and fire down on the attackers with arquebuses (a muzzle-loading firearm) and crossbows.

Spanish ships were not designed to withstand the recoil of a cannon, which were mounted on two-wheeled carriages like shore-side artillery. Cannon fire was used more for psychological effect than any ability to damage enemy ships.

The high castles impeded the ability of ships to sail effectively. They created what sailors call "windage" where the hull of the ship catches the wind, which pushes the ship sideways. Thus Spanish ships sailed to windward very poorly. The French pirates at Fort Caroline reported success in seizing small Spanish vessels without castles and remarked on how agile they seemed to be compared to the larger caravels.

Hawkins noted this and returned to England not only with his pirated Spanish loot and French cannon, but also with ideas about improving ship design. He suggested removing the forward castle and using the timber to strengthen the hull and create a strong gun deck. Five years later, in 1570 his first "galleon" was under construction. It could outsail the older medieval designs, and was able to batter them with gunfire instead of closing for hand-to-hand combat.

In 1588, a small fleet of Hawkins's new ships—dubbed "racing galleons"—would meet and defeat the Spanish Armada. The Spanish were attempting an amphibious invasion of England to end British support for the Protestant revolt in Northern Europe. The 1588 battle between the medieval ships of Spain and redesigned galleons of Hawkins put an end to Spain's attempt to claim Europe in the name of Catholicism. It is very likely those smuggled cannons from Florida were used aboard Hawkins's racing galleons.

Soon after Hawkins's departure from Fort Caroline, the 1565 race between the Spanish and French fleets to Fort Caroline ended in a tie on September 4. After a skirmish, the French fleet was scattered by a storm. Menéndez landed troops, captured Fort Caroline, killed most of the Protestants and marched south to establish a colony he called St. Augustine—the oldest continually occupied city in North America. The political fate of Florida for the next two hundred years was decided.

The French colony is also notable for another long-lasting reason. It introduced Hawkins (and the world) to tobacco. "The Floridians when they travell, have a kinde of herbe dried, who with a cane and an earthen cup in the end, wiuth fire, and the dried herbs put together, doe sucke thorow the cane the smoke thereof, which smoke satisfieth their hunger, and therewith they live four or five dayes without meat or drinke, and this all the Frenchmen used for this purpose: yet do they hold the opinion withall, that it causeth water and fleame to void from their stomacks," wrote John Sparke Jr. in "The Voyage Made by M. John Hawkins, Esq.," in *Voyages*, edited by Richard Hakluyt and originally published in 1589.

Tobacco would become contraband for future smugglers worldwide, but that's another story. In the case of Florida, tobacco smuggling became a politically charged issue four hundred years later when President John Kennedy bought up all the Cuban cigars in Washington, then signed an economic embargo against the island, opening up yet another venue for smugglers.

AMERICA'S HUNDRED YEARS' WAR

Because smuggling is a covert activity, records of successful smuggling do not exist. The example of the Seminole Wars in Florida is a perfect case in point. Historians are still searching for proof that the Spanish secretly supplied the Seminoles with arms, powder and shot. Certainly somebody did, for a state of war—from the Indian point of view—lasted from 1756 until the 1858 surrender of Billy Bowlegs and his forty warriors. Call it America's Hundred Years' War.

The British were the first to supply the Native Americans with arms because the two were allied against the Spanish during the Seven Years' War (many Americans call it "the French and Indian War") from 1756 to 1763. Raids against Spanish missions in the panhandle were so successful that only St. Augustine remained untouched and Florida became a British possession when the peace was signed.

During the American Revolution and the War of 1812, Native Americans in southern Georgia and Florida remained pro-British. Despite the end of the War of 1812, American General Andrew Jackson continued raids against Native Americans in British Florida. American history books call this the First Seminole War.

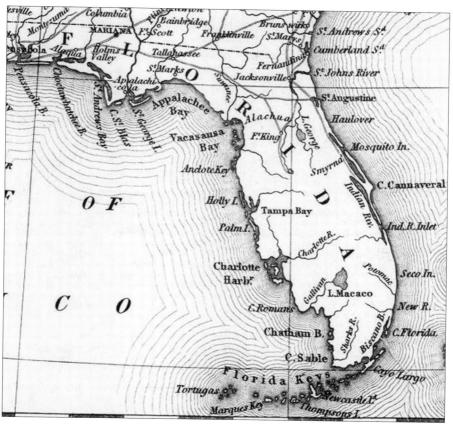

This 1835 map from the start of the Second Seminole War shows a wide-open frontier with little or no settlement south of the panhandle. The abundance of unpopulated waterways—with friendly Cubans amidst the islands of the western coast—provides a geographic hint of how the Seminoles obtained guns, powder and shot despite a U.S. Navy blockade. *Courtesy University of South Florida.*

That war ended in 1819, when the British ceded Florida to the United States. By this time, many Native American tribes in southern Georgia had been pushed out of their homelands by American settlers. Most went west, but some fled south to central Florida where they reestablished villages.

At the same time, the identity of Native Americans in Florida began to change, as a variety of southeastern tribes—mingled with escaped African American slaves—fled into central Florida. They became known as "the Seminoles." The term has various translations. In Spanish (from "Cimarrone") it means "runaway." The British preferred "the wild ones," while the Seminoles then and today preferred the translation "pioneer" or "adventurer."

When the British ceded Florida to the United States, it was practically unoccupied. The original inhabitants were virtually wiped out by five Spanish expeditions bringing disease, pillage and death (Ponce de León, Pánfilo de Narváez, Hernando de Soto, Tristán de Luna y Arellano and Pedro Menéndez de Avilés). The British raids on the Spanish panhandle missions completed the extermination. By the beginning of the Second Seminole War in 1835, the population of the entire United States was 12.8 million. Of that total, only 34,730 lived in Florida.

With the British gone, the Seminoles found other sources of ammunition and powder for their muzzle-loading muskets. The U.S. government suspected Cuba was the source and dispatched the navy to impose a cordon. Despite years of sailing relentlessly back and forth between Cuba and Florida, the U.S. Navy did not intercept a single ship carrying arms bound for the Seminoles.

By raiding outposts and settlements, the Seminoles secured some powder and shot. For example, in a daring raid on August 6, 1840, a war party canoed thirty miles across Florida Bay and attacked the settlement on Indian Key. The amphibious Indian invasion frightened the settlers, who took to their own boats and rowed to the safety of a ship anchored in the harbor. A nearby navy detachment of twelve men rowed two barges into the fray. The Seminoles loaded up the settlement's cannon and fired at the barges in what was perhaps the first instance of Indian use of artillery. The navy—outnumbered and outgunned—retired. The Seminoles burnt the settlement, loaded four barrels of gunpowder and a supply of musket balls into their canoes and paddled off into Florida Bay.

Those four barrels, however, were not sufficient to keep the Seminoles fully armed. It is likely their good relations with Cuban fishermen along the lower west coast of Florida—whose settlements were never harmed—were the source of their arms, but this has never been proven.

Although the number of warriors never exceeded one thousand and they rationed their munitions carefully, somebody kept the Seminoles in powder

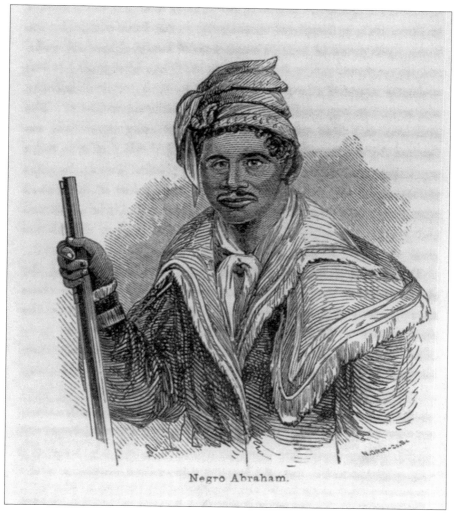

Negro Abraham.

As the Europeans pushed west from the eastern seaboard, some Native Americans fled south into unoccupied Florida. They accepted African runaway slaves into their emerging Seminole society, as all fought to keep their freedom. This is an engraving of "Abraham, a Negro interpreter who lived with the Seminoles." *Illustration in "The Exiles of Florida" by Joshua Reed Giddings, 1858. Courtesy Library of Congress.*

and shot for the decades after the British departed from Florida. Whether it was sympathetic Cuban individuals or a covert plan by the Spanish government is unknown. But it provides an interesting leitmotif to the major expansion in arms smuggling in the following century. Today's insurgents face the same problem as the Seminoles: where to get arms and munitions? For Central and South America, the answer often is Florida.

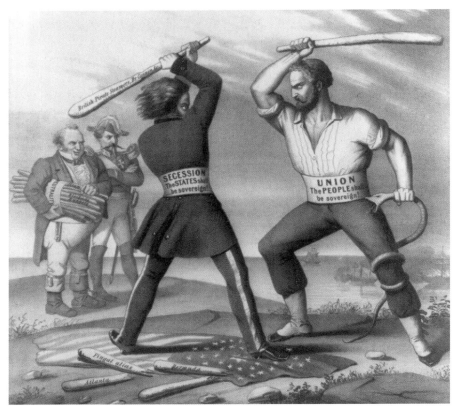

In 1861 cartoonist Oliver Evans Woods portrayed the Confederate strategy. The North and South fight as England and Spain look on, ready to provide the South more tools, including blockade runners and steam rams. The Southern character is wielding a cudgel labeled, "British pirate steamers, British cannon etc." Note the burning ships behind the Union fighter. *Cartoon by Oliver Evans Williams, 1861, revised 1863. Courtesy Library of Congress.*

For the record, the Seminole tribe signed an agreement with the United States in 1957. The U.S. government recognized Indian sovereignty over Indian lands and agreed to pay compensation for past wrongs. A formal peace treaty was never signed. The Seminoles remain America's only unconquered native people.

PROFIT, NOT GLORY

Not all arms smuggling in Florida was successful. The blockade runners of the Civil War found to their dismay that smuggling guns to the Confederacy was actually a losing proposition.

When the Civil War (or the War Between the States as it is still known in the South) erupted, the Confederate States contained virtually no heavy industry. It had only eleven rolling mills and no capacity to manufacture machine tools. The entire Confederacy, in fact, had less manufacturing capacity than New York City and there was no supply of iron ore. To build a railroad line in one location, the Confederacy had to tear up another line someplace else.

The Confederate government looked abroad for help. The Union navy quickly established a blockade along the coastline and captured several Florida ports. Key West, the state's largest city, remained in the Union and provided a vital naval base for the blockading fleet. Sensing a big customer, smugglers called "blockade runners" started running guns and munitions.

Initially the Union blockade was easy to run. A few large Federal warships were posted off the South's major ports such as Savannah and Charleston. Four nearby neutral ports allowed blockade runners easy access to Florida without making long overseas voyages. These neutral ports were Bermuda, Nassau, Havana and Matamoros in Mexico. Nassau is only 180 miles and Havana only 90 miles away from Florida.

However, the Confederacy had no readily accessible Florida ports after early 1862 because they were all in Union hands. Those captured ports, including Fernandina and St. Augustine, served as bases for the blockading squadrons, greatly simplifying the process of fueling the Union steamers.

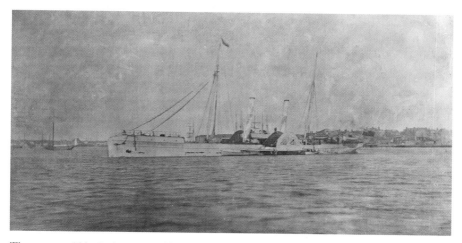

The captured blockade runner *Teaser* gives an idea of the design and cargo capacity of the ships supplying the Confederacy. The narrow hull and large "side wheels" promise a good turn of speed. Ships like *Teaser* would be used to transship cargoes from the Bahamas. During the Civil War, oceangoing cargo vessels continued to be sail-powered. *Glass Negative. Collection of the Library of Congress, 1864.*

The blockade runners adapted by choosing small inlets where boats could dash in, unload and dash out again. The Union blockade fleet patrolled the coast, looking for such "dashers." When they were discovered, marines were sent ashore to burn the "dashers." Each instance was of little import, but the cumulative effect was profound. Floridians found it difficult to replace so many burnt boats.

During the early years of the war, blockade runners brought in substantial quantities of arms, ammunition and other military supplies, which the Confederate government bought at fixed prices. The smugglers soon realized that vastly greater profits could be made smuggling luxury goods into Southern ports at premium prices. These luxury items, such as cloth and sewing thread, were paid for with either gold or cotton. Wars never stop fashion.

This switch in cargoes had several negative effects on the Confederacy. It reduced the amount of military supplies available as blockade runners switched from munitions to millinery goods. It cut deeply into the new nation's gold reserves, undermining the convertibility of its currency. In turn, that started inflation, which eventually ruined the Confederate economy. The Confederacy's concept of "fixed-price gunrunning" as a national strategy proved a disaster.

THE GUNRUNNING GOVERNOR

We are free, but not to be evil, not to be indifferent to human suffering, not to profit from the people, from the work created and sustained through their spirit of political association, while refusing to contribute to the political state that we profit from. We must say no once more. Man is not free to watch impassively the enslavement and dishonor of men, nor their struggles for liberty and honor.
—José Martí

The late nineteenth century saw guns running in the other direction—from Florida to support Cuban insurgents fighting for freedom against the Spanish. The most notable of the gunrunners would go on to become Florida's governor.

At the end of the nineteenth century, thousands of Cubans lived in Florida. Many worked in the cigar factories of Tampa. Rolling cigars was a tedious but well-paid trade; to break the tedium, the cigar workers often hired "readers" to sit on a stage in the factory. As they daily rolled and trimmed America's favorite tobacco product, they learned history, listened to poetry, enjoyed romance and trembled to drama—all in the Spanish language.

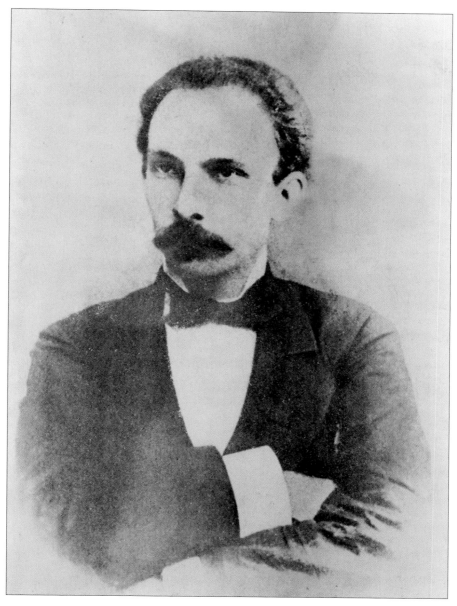

José Martí remains an icon in Central and South America. He was an excellent fundraiser and revolutionary poet. Cuban-American cigar workers taxed themselves to buy guns for the insurrectos trying to bring down the Spanish colonial government of Cuba. All of them—the workers, insurrectos and Martí—created the domestic political climate inside the United States that led to the Spanish-American War of 1898. *Halftone portrait published 1890–1920. Courtesy Library of Congress.*

One of the poets who enjoyed wide popularity in the cigar factories was José Martí. He was born in Havana in 1853. At the age of seventeen, he was expelled from Cuba for his political activities. He traveled to Spain and began a career as a poet, writer and democratic activist. He returned to the New World and worked through several Central and South American nations, always one step ahead of the political police. He came to New York City in 1881. If Simón Bolívar is considered the George Washington of South America, José Martí is its Thomas Jefferson.

Martí actively sought financial help from his fellow Cubans across America. Through personal appearances and the reading of his words, workers in Florida's sixty-one Cuban cigar-making factories voted to levy a 10 percent "tax" on their wages to support the insurrection in Cuba. Cuban organizations in New York and other cities provided similar financial support.

The Cuban Revolution started on January 29, 1895, at a secret meeting in New York. A message was handwritten to Juan Gomez, leader of the insurrectos in Cuba. The message traveled to Tampa, where it was rolled inside a cigar. Cuban schoolchildren know this story as "the cigar of liberty." Gomez was instructed to start the revolution on February 24, 1895.

The firebrand Martí went back to Cuba to join the rebellion. Only a month after it began—on March 23—he was killed in an ambush by Spanish troops. Martí to this day is revered as a Cuban patriot, a hero and a touchstone of Cuban nationalism. His poems are still in print, and in Cuba and Latin America his work remains popular.

Also in 1895, Napoleon Bonaparte Broward commissioned the construction of an oceangoing tugboat called *The Three Friends*. Broward was a licensed pilot for ships crossing the ever-shifting sands of the St. Johns River inlet to the Atlantic. He was also a "filibuster," a term used in the nineteenth century to describe Americans who tried to overthrow foreign governments.

During construction, Broward was approached by a member of the Jacksonville expatriate Cuban community to run a load of guns to the insurrectos attempting to overthrow the Spanish colonial government. In 1896, *The Three Friends* embarked on its maiden voyage, bound for Cuba with a cargo of weapons, a trip it repeated several times.

The Spanish government demanded the United States stop Broward, yet he eluded not only the U.S. Navy but also Spanish gunboats. Several times he was intercepted by the Spanish but managed to escape.

In American waters, Broward loaded his cargoes in the dead of night along the St. Johns River from small barges provided by Cuban expatriates. He then sailed out of the river by hiding behind larger ships. Because

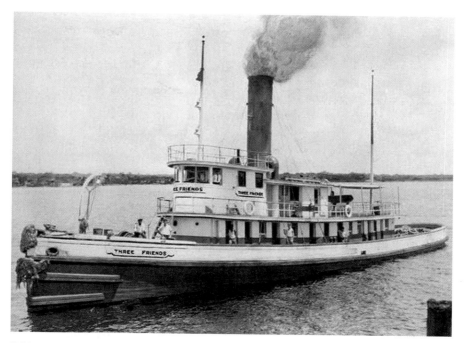

Seldom has a smuggling activity received more publicity and acclaim than Napoleon Broward's arms trafficking to Cuban insurgents from 1895–1898. It helped sweep him into the governor's mansion. Broward's powerful *Three Friends* tugboat repeatedly carried arms to Cuba with Broward at the helm. *Courtesy the Florida Archives.*

support was strong in Florida for the insurrectos, Broward gained statewide notoriety. When the Spanish-American war began in 1898, his services as a gunrunner were no longer required.

In 1903 Broward decided to run for governor. Neither Broward nor his liberal backers were wealthy. They faced Robert Davis, the well-financed candidate of railroad baron Henry Flagler. Broward stumped relentlessly through Florida's villages and towns. "I don't intend to go after the cities. Their newspapers are against me and they don't take me seriously. But I'm going to stump every crossroads village between Fernandina and Pensacola," he said.

At the time, Florida was a stronghold of the Democratic Party and elections were decided at the primary level. When the dust settled in November of 1904, Broward beat Davis by 600 votes (out of 45,000 cast) to become Florida's nineteenth governor. Broward's big campaign promise was drainage of the Everglades. A century later, the nation is trying to undo that mistake and still has major problems with the government of Cuba.

MAK-90S, SCUDS AND NUKES

While Cuban smugglers brought arms to the Seminoles and blockade runners carried munitions to the Confederacy, Broward and modern arms dealers moved guns in the other direction, from Florida to Cuba and the world at large. It is a game anybody can play today, because Florida is a wide-open market for the weapons desired by criminals, rebels, insurgents and terrorists around the world.

An investigative report on the Public Broadcasting Service (PBS) in 2002 followed the curious tale of Lobster Air International. The broadcast was summarized in the December 22, 2002 issue of *The Nation* in an article called "The Guns of Opa-Locka."

"In the summer of 1998 Stephen Jorgensen began buying the first of what were eventually more than eight hundred MAK-90 semiautomatic rifles at a store called Gun Land in Kissimmee, Florida. He did not have a resale permit—known as a Federal Firearms License (FFL)—and he was not required to present one," wrote Jake Bergman and Julia Reynolds in *The Nation.*

"But Jorgensen wasn't stockpiling the guns for his personal use; he was taking them to Opa-Locka airport near Miami and loading them aboard a light airplane headed for airstrips in Venezuela and Colombia, via Haiti," they wrote.

MAK-90 stands for Modified AK, as in AK-47, the assault rifle made famous by the Viet Cong in Vietnam and later adopted worldwide by other insurgents. The "90" stands for 1990, the year the Chinese arms manufacturer Norinco modified the AK-47 to create the MAK-90. The redesign was required because in 1989, the U.S. Congress slapped an import ban on assault rifles. Norinco redesigned the AK-47 to slip through the ban, and it sold very well throughout the United States. All the AK-47 accessories fit, including the thirty-round "banana clip," the hundred-round drum magazine and sniper scopes. The Norinco version cost only $250, about one-tenth the value of a bona fide Russian AK.

Jorgensen purchased a Rockwell Aero Commander, a high-winged, twin-engined aircraft with a cargo capacity of two thousand pounds. It was designed in the late 1940s. He established a company called "Lobster Air" because it allegedly shipped live lobsters from Haiti to Florida. But Haiti was only a stopover on the longer trip to Venezuela.

Jorgensen's adventure came to an end when U.S. Customs agents, acting on a drug tip, showed up at Opa-Locka airport and halted his takeoff. Instead they found seventy-eight MAK-90s in blue gym bags and nine thousand rounds of ammo. The article cites sources saying the guns were

intended for Colombia's FARC rebels, a group on the U.S. Department of State's list of terrorist organizations.

Jorgensen turned the state's evidence against the ringleader—a lieutenant colonel in the Venezuelan Air Force—and received only probation. His crime was violation of the Arms Export Control Act.

These guns have had deadly consequences. In 1985 Colombian rebels from the group M-19 attacked the Palace of Justice and killed 115 people, including 11 Colombian Supreme Court justices. All the guns used were eventually traced back to Florida.

There seems to be a direct correlation between large arms shipments leaving Florida and foreign violence. The magazine article quotes Daniel McBride, an Alcohol, Tobacco and Firearms agent. "We would see, all of a sudden, a rash of large gun purchases, a large quantity of gun purchases throughout South Florida. We would find that then, a month or two months later, we would see a coup take place in Haiti," he said.

Jorgensen and his "Lobster Air" is a mere wrinkle in the fabric of Florida's trade in arms. Until recently, Fort Lauderdale resident Jean Bernard Lasnaud could sell you a SCUD ballistic missile—or a mobile field hospital to bandage all the people injured by the machine guns, rocket launchers, fighter planes, rifles, mortars and grenades he has sold. Lasnaud lived openly in South Florida until 2002.

With his bow tie and facile smile, the French-born Lasnaud looks nothing like a merchant of death. However he has been linked to illegal arms transfers to some of the bloodiest lands of the twentieth century, including Somalia, Croatia and Ecuador, in violation of international arms embargoes.

Lasnaud was the subject of PBS investigation. The news documentary *Frontline/World* in May 2002 found Lasnaud was tried in 1983 and sentenced in absentia in Belgium for illegal arms transfers. *Frontline/World* reported:

> *Lasnaud now stands accused in Buenos Aires courts of brokering sales of Argentinean weapons to Croatia and Ecuador from 1992 to 1995, in violation of U.N. and international embargoes. As a result, in 1999 Interpol issued a 'red notice' for Lasnaud, a high-priority request for immediate arrest and extradition. 'An Interpol red notice is the closest instrument to an international arrest warrant in use today,' says the U.S. Justice Department Web site. A red notice has been issued for Osama bin Laden—and for hundreds of accused arms dealers, murderers and drug traffickers most people have never heard of. For nearly three years, the Justice Department has deviated from standard extradition procedure and has refused to arrest Jean-Bernard Lasnaud,*

curiously citing lack of evidence. Argentinean prosecutors are stunned at this refusal; a documentary trail of faxes, money transfers and e-mail points to Lasnaud's knowledge and participation in the sales.

A mid-1990s case in Ecuador proved Lasnaud's undoing, along with his local partner, Argentine Navy Captain Horacio Estrada. Ecuador and Peru were in a border war in 1995. Under terms of the Rio Protocol of 1942—which ended another border war between Ecuador and Peru—Argentina pledged not to supply arms to either party. A secret shipment to Ecuador blew up into a major political scandal in Argentina. Some of the 9 million rounds of ammunition were faulty and some of the 7,500 rifles were defective. Ecuadorian officials were incensed and believed Estrada and Lasnaud were pawning off the dregs of Argentina's armories.

By the late 1990s, Argentine prosecutors were investigating. They interviewed Estrada, who denied doing any business with Lasnaud. A few days later, Estrada was found shot dead in his Buenos Aires apartment, *Frontline/World* reported. Local police ruled it a suicide. Argentine authorities issued the "red notice," but the United States paid no attention. *Frontline/World* reported:

Argentinean prosecutors wonder, then, why the U.S. never arrested Lasnaud, an arms dealer accused of secretly brokering weapons smuggled around the world. Jeffrey Denner, a criminal defense attorney who helped rewrite the U.S.–U.K. extradition treaty, says that it is common procedure to make an immediate arrest in such cases, because the aim is to make sure the suspect doesn't flee. At that point, Denner says, questioning the other country's evidence is rare. 'It's not up to us to decide whether he's guilty under Argentinean law. There's some basic due process that has to be covered, but beyond that, it's just not something we look into, ever.'

The *Frontline/World* broadcast cited several sources indicating Lasnaud probably was also working with American intelligence services. "Another source in the U.S. Attorney's office in Miami says that when the Justice Department does not honor a red notice in the usual procedural manner, there 'must be something else going on' related to U.S. national security or U.S. intelligence agencies," it reported.

In fact, Lasnaud was promoting U.S. interests when he arranged for some of the "excess" Argentinian weaponry to be smuggled into Croatia in violation of a United Nations arms embargo. The United States wanted to halt ethnic cleansing by Yugoslavia's government in the breakaway Muslim republic and was under significant diplomatic pressure by several Middle

Eastern nations. However, an arms embargo was in place, so the U.S. government had to turn to Lasnaud.

Frontline/World reported: "Dr. Daniel Nelson, a former arms proliferation consultant to the State Department, was in Croatia during the time of the sales. Nelson says that in the early 1990s, the U.S. was in favor of arming Croatia but did not want to openly violate the U.N. embargo; instead, officials simply 'winked' at weapons shipments from Argentina, South Africa, Hungary, Slovenia, Bulgaria, Poland, Ukraine and Iran. 'U.S. people were engaged in trying to find sources [of arms]—Islamic, and those that weren't. And Argentina was one of those,' Nelson says."

After fleeing his gated community in Fort Lauderdale in 2002, Lasnaud was arrested in Geneva, Switzerland, and extradited to Argentina, where he was questioned. The online newspaper *Los Andes* reported on October 12, 2004, that Lasnaud was released and left Argentina. His whereabouts are now unknown.

The case of Lasnaud displays the uneasy relationship between governments and private arms smugglers. "A former U.S. intelligence agent stationed in Latin America tells *Frontline/World* he has confirmed that Lasnaud has been a CIA asset 'since the Iran-Contra days,' but says it is unclear whether he still has that status," the broadcast reported. Lasnaud's easy life in Fort Lauderdale under protection of the U.S. government while facing a red notice is just one benefit of working at the interface between private business and government intelligence. And where, I wonder, is the SCUD missile Lasnaud posted for sale on his website?

WANNA BUY THE BOMB?

At approximately the same time Lasnaud was smuggling bad ammo to the Ecuadorians, a Lithuanian in Miami was proposing to sell Russian Strela missiles (similar to the U.S. Army's Stinger—shoulder-fired, ground-to-air, anti-aircraft missiles) to a Colombian drug cartel. At least Alexander Darichev thought he was selling to the Colombians. His customer was actually a U.S. Customs agent setting up a Miami sting operation.

The customs agent established a phony corporation called Phoenix International, sent a representative to Lithuania to look over the merchandise and established bank accounts on the Isle of Man to facilitate the transfer. The all-important End-User Certificate was signed by the (soon to be disgraced and former) Lithuanian Defense Minister. Using the bogus documentation, the missiles were to be shipped from Bulgaria to Puerto Rico.

Darichev asked the agent if, after the missiles were delivered, he would be interested in small nuclear weapons. The question released a bombshell in the U.S. national security organization. Weeks of intense bureaucratic negotiation ensued before it was decided to terminate the sting and not pursue the nuclear offer.

On June 30, 1997, Darichev and his confederate Aleksandr Pogrebezskij were arrested. One element of their indictment was unique in American history: an offer to procure nuclear weapons. "It was further part of the conspiracy that defendants, Aleksandr Pogrebezskij and Alexander Darichev, would offer to procure and broker the sale of tactical nuclear weapons upon the completion of the missile systems sale," the indictment said.

Darichev received a sentence of four years and agreed to cooperate with prosecutors. They later confirmed forty more anti-air missiles were awaiting shipment in Bulgaria, having made their way from Lithuania.

Radio Free Europe/Radio Liberty on July 2, 1997, intercepted a Radio Bulgaria broadcast denying any wrongdoing by either the arms manufacturer or the ministry of trade. "The ministry says the deal did not go through because payments were never made. Bulgarian authorities say Aleksandr Darichev, who was recently arrested in Florida by U.S. agents, worked as a representative of Phoenix Arms International. The ministry also says Darichev's firm presented all the documentation needed to legalize the purchase," the state-run broadcast reported.

While the customs agents were stopped from pursuing "loose Russian nukes," their easy ability to obtain more than forty anti-air missiles demonstrated the ease with which terrorists could purchase them. While designed to attack military helicopters and other low-flying aircraft, such missiles could be useful in attacking commercial airliners at takeoff and landing.

Florida's career in arms smuggling starts with the founding of the first European colony, includes a three-hundred-plus-year state of war with Native Americans, features a Florida governor with a gunrunning past and concludes as the home base of international arms traffickers offering ballistic missiles and nuclear weapons. Its munitions traffic has also indirectly saved religious tolerance, replaced governments, destroyed the Confederate economy and now supplies just about anything to just about anybody. Whether the guns are coming in or going out, Florida seems always to be a player in the international arms bazaar.

FOUR

HOMEBREWS, HAMS AND RUMRUNNERS

Americans have always liked their liquor. In 1792 the young republic had about 4 million citizens, and consumed about 11 million gallons of booze (about 3 gallons per capita). By 1810 the population was 7.2 million and consumption was 33.3 million gallons (closer to five gallons per head). These figures are "official gallonage," a combination of taxed domestic output and legal imports. Any homemade liquor—moonshine whiskey or ice brandy—is not part of the calculation.

As Herbert Asbury notes in his *The Great Illusion: An Informal History of Prohibition*, in the young republic everybody drank hard liquor: "The aged and infirm sipped toddies of rum and water—heavy on the rum; babies were quieted by copious doses of a mixture of rum and opium, and so spent their infancy in a happy fog; and able-bodied men, and women too, for that matter, seldom went more than a few hours without a drink. The occasional abstainer was considered a crackpot and generally shunned."

Despite this early predilection to liquor, a temperance movement emerged. Its wellsprings predated the revolution. Liquor was banned from the new colony of Georgia between 1735 and 1742 by the colonial governors in London. When news reached the settlers, they immediately stopped creating a colony and began making homebrew moonshine (probably America's first illegal stills).

The colony's principal source of supply, however, was enterprising shipowners who sailed from South Carolina with casks of rum for the thirsty Georgians. This pattern would be repeated nearly two hundred years later when the entire country banned liquor and other daring entrepreneurs sailed in to satisfy a thirst.

Congress did not wake up one morning and decide to make the country "dry." It reacted to more than a century of organized pressure groups. Shortly after the American Revolution, a collection of Connecticut farmers formed a temperance association to promote moderation in alcohol consumption. Not abstinence, but moderation.

This poster is from 1949, but the tone is identical to ones posted during Prohibition. Not only does it urge the public to report makers of untaxed whiskey, but it also has a secondary message—would you drink the product of these people? *Courtesy Library of Congress.*

As the nineteenth century began, more temperance groups were formed. After the Civil War, the Women's Christian Temperance Union was established. The WCTU did not want "moderation," it wanted "prohibition." As a tactic, it urged public education on the evils of alcohol. By the beginning of the twentieth century, every state had laws mandating "alcohol education" in public schools. The effort was closely monitored in the classroom by members of temperance societies.

Alcohol abuse was (and is) closely related to domestic violence. Nineteenth-century wives noticed their husbands beat them more frequently when the men were drunk. Other causes took up the banner of prohibition, viewing the high price of alcohol as one reason for widespread poverty. Alcohol was also viewed as a major incubator for violent crime.

Georgia came to the prohibition forefront again in 1907. The state legislature passed the first statewide "dry law" in the South, banning the sale of beer, wine and liquor at the urging of the Anti-Saloon League. Other Southern states quickly followed, including Mississippi, North Carolina, Tennessee and Virginia. But not Florida.

The dry wave crested with the adoption of the Eighteenth Amendment to the U.S. Constitution in January 1919. It criminalized booze for the entire nation. Only two states—Rhode Island and Connecticut—refused to ratify the amendment.

At the beginning of Prohibition, the radio evangelist Billy Sunday said, "The slums will soon be only a memory. We will turn our prisons into factories and our jails into storehouses and corncribs." Just as the abolition of slavery was an effort at social engineering to rid the country of a great evil, so was Prohibition an attempt to regulate society by action of law. The Volstead Act passed later in 1919 to enforce the Eighteenth Amendment and President Woodrow Wilson vetoed it. Congress passed it over his head by overriding the veto.

When national Prohibition went into effect on January 16, 1920, more than 180,000 saloons, 1,217 breweries and 517 distilleries closed their doors. The national population was 105 million, while the population of Florida counted by the census takers was 968,470. Less than one of every one hundred Americans lived in Florida. Miami was a small town of 30,000 souls and Tampa's population was 52,000. But tiny Florida would soon become a liquor lifeline to the nation.

Four areas in the United States became the principal sources of smuggled alcohol. Two relied on land transport: Chicago and Detroit. Two relied on the sea: New York and Florida. Unlike the other three sources, Florida escaped the clutches of organized crime. The booze trade in Florida, like the marijuana trade that followed it, remained a hometown business.

51

This is the 1923 government chart used by all the rumrunners between the Bahamas and Florida's east coast. The seventy-mile gap between the two countries is small, but not easy to navigate. The Gulf Stream can produce strong winds and high seas at any time of the year. Fifty years later, pot haulers and cocaine cowboys would use the same route. *Courtesy University of South Florida.*

The principal source of all the liquor was Grand Bahama Island, sixty miles from Palm Beach. In 1921 the Grand Bahama town of West End boasted nine liquor warehouses, and the government was reaping an excise tax of six dollars per case. In the harbor, forty or fifty speedboats waited for good weather to make their next dash to Florida. A small fleet of aircraft also waited at West End to make their deliveries.

In 1917, before Prohibition began, the islands imported about 50,000 quarts of liquor. In 1923, the Bahamas imported 10 million quarts and received revenues of more than £1 million. The Bahamian excise tax was plowed back into the island chain for roads, schools, water supplies and other civic improvements. Prohibition was the biggest boon the Bahamas had ever seen. The islands became, for a time, the major source of booze for the eastern seaboard.

East of Miami lies Bimini, another liquor supply point, except here the booze was held on barges with living and sleeping quarters for guards. Another fleet of speedboats, often built in Miami and powered with army-surplus Liberty airplane engines, waited to make the two-hour crossing. The U.S. Coast Guard had nothing fast enough to catch them.

Florida's west coast participated in the booze bonanza too. "For 16 years scores of 'black ships' operated off the coast of Tampa Bay bringing in unlawful liquor," wrote Frank Alduino in the *Journal of the Tampa Historical Society* in November 1990. "Skillful sea captains, financed by both legitimate business concerns and criminal organizations, risked possible arrest and the impounding of their vessels for high profit yields. The main source of Tampa's liquor supply came from Cuba and especially the Bahamas."

Waiting ashore was "the key man," sometimes a local businessman and sometimes a gangster. He recruited local boaters to bring the booze ashore and with friends and associates loaded the contraband into cars and trucks. "One former Tampa bootlegger recalled that in order to avoid suspicion, he and his cohorts borrowed trucks belonging to a local merchant. Bootleggers were well paid. The 'Key Man' usually received a dollar a case for his services, while his associates were given about $25 a night," Alduino wrote.

James Carter wrote in the January 1969 *Florida Historical Quarterly*, "The citizenry of the state consumed its fair share of the liquid, but most of it was destined for northern cities. Often it was camouflaged as fish, citrus fruit, or vegetables. Such traffic was difficult to suppress; it was impossible to search every car and truck on the highways."

In addition, like their brethren across the nation, Floridians set up their own stills but with a key advantage. Sugar cane grows well in south Florida, and sugar is an essential ingredient in moonshine.

"The sons of the plume hunters were moonshiners and rumrunners, including the old Chokoloskee preacher. The moonshine was made from locally grown sugarcane. The rum came from the Bahamas; it was wrapped in burlap packages called hams and transferred from offshore mother ships to the fishermen's small boats, then brought inland for distribution," Totch Brown recalled in his autobiography of growing up in Everglades City. Once the hams reached the railroad, they were repackaged in tomato crates and dispatched to points north. By the beginning of Prohibition in 1920, the railroad ran down the west coast of Florida all the way to Everglades City.

The hams were the creation of Captain William McCoy, one of the two iconic figures of Prohibition (Al Capone is the other). McCoy was a tall, handsome, teetotaling Miami sailor. He was born in upstate New York and came to Florida in 1898. By 1920 he and his brother ran a line of marginally profitable powerboats and coastal freighters. They sold their boats and bought a fishing schooner named *Henry L. Marshall.*

In February 1921, Bill McCoy left Jacksonville aboard his ninety-foot fishing boat and sailed to Nassau. There he loaded the boat with 1,500 cases of prime liquor. The booze was purchased by a merchant, who promised McCoy ten dollars per case if he could deliver. At West End, McCoy paused to reregister the boat to sail under the British merchant ensign. He left in a gale, bound for St. Catherine's Sound, south of the Savannah River near the Florida–Georgia border.

The schooner arrived at night and was soon met by smaller boats. The *Marshall* was unloaded and soon McCoy was back in Nassau, $15,000 richer. He sold *Marshall* and bought something bigger, then bigger and then bigger still. Over the next four years, he would run 175,000 cases of illicit liquor and land a place in history.

His first contribution to rumrunning was devising how to repackage all those bottles. The booze came in wooden crates, which were awkward to stow and difficult to transship to smaller boats at sea. McCoy devised what was known as a ham or burlock. Straw was put at the bottom of a burlap bag and three bottles were set inside; two more bottles were added upside down; a sixth bottle was put on top, right side up. More straw was added and the bag was stitched shut. You could carry three times the number of bottles as "hams" as you could in wooden cases. This was a major boon to productivity and the bottles actually were safer in straw and burlap than in crates.

McCoy's second innovation—at least he took credit for it—was the creation of "Rum Row" offshore of Manhattan. As long as the rumrunners stayed beyond the three-mile limit, they were immune from interference by the U.S. Coast Guard. The British registration was a further deterrent, as

the U.S. government did not want to create an international incident on the high seas.

Off the coasts of New York, New Jersey and to a lesser extent San Diego, rows of mother ships would park outside the three-mile limit and wait for wholesale customers to tie up and shop. The mother ships would load up in Nassau or ports in Cuba. "In fact, the whole West Indies was dripping with booze, most of which was eventually smuggled into the United States," wrote Asbury. As ships ran empty, they were replaced by ones with full cargoes.

The coast guard caught many of the smaller, slower boats circulating between Rum Row and the shore, but the speedboats were untouchable. In keeping with the times, there were shootouts, daring escapes and general excitement on the water as the coast guard and local police attempted interceptions.

Drinkers viewed the Rum Row ships with pleasure, thinking they were getting prime booze, but that wasn't the case. Asbury estimates for every gallon aboard, ten gallons were produced by cutting the real product with industrial alcohol. An enterprise emerged to create fake bottles—with fake labels and even fake tax stamps—and fill them with strange and even noxious mixtures aboard the Rum Row ships.

A common question for any boat owner is, "How many will she sleep?" In the case of this Prohibition-era skipper, the question takes a different meaning. Transferring booze from Rum Row to shore was the task of any number of vessels, from rowboats to the sleek yacht seen in this cartoon "150 Cases" by John Conacher in *Life* magazine. *Courtesy Library of Congress, Conacher Collection #87.*

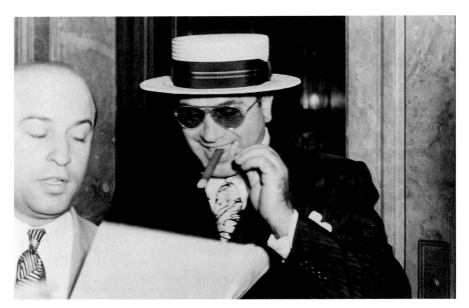

In this undated photograph, a young Al Capone leaves the Federal Building in Miami with his attorney Abe Teitelbaum. With his sunglasses, flashy tie, Havana cigar and straw boater, Capone looks every inch the wealthy tourist. *Courtesy Library of Congress.*

Capone was an organized crime pioneer in several respects. His early appreciation of Florida, for example, paved the way for Miami to become a "neutral ground" for organized crime. In Miami, crime bosses from all of America's major cities could relax and enjoy themselves without fear of reprisal or retribution by rivals. One of the places they could relax was Big Al's estate on Miami Beach. *Courtesy Library of Congress.*

But McCoy would have none of that. His business hallmark was fair dealing and led to the term "the real McCoy." Bill's booze wasn't watered or re-labeled. It was what it proclaimed itself to be, and people started calling it "the real McCoy"—his third contribution to American history.

(Like many Prohibition stories, this "real McCoy" is open to debate. It is likely the term originated with Elijah McCoy, a Canadian who invented a self-lubricator for steam engines, both railroad and marine, in 1872. Railroad men began to ask if lubricators were "the real McCoy." Without question, Bill McCoy also used the term for his uncut liquor.)

McCoy somehow managed to escape the coils of organized crime. While he would sell freely to the bootleggers, he never paid any protection money to them or favored one over another. In John Kobler's *Ardent Spirits*, he quotes McCoy as saying, "Dealings of that sort would have killed the sport of the game for me."

In 1923 McCoy was indicted by a federal grand jury, tried in 1925 and served nine months in Atlanta Federal Prison. Upon release, McCoy surveyed the market and decided he didn't want to compete with the major crime syndicates that consolidated all the business. In addition, in 1924 the United States and Britain agreed that the coast guard could search British-registered vessels. So McCoy returned to Florida, began a successful real estate business (what else?) and died of a heart attack in 1948.

The big profits during Prohibition were not made by the smugglers, but by the shoreside organizations that handled the cutting, repackaging, distribution and eventual retail sale. There were hundreds of these organizations. Often they would cooperate, but sometimes conflicts were settled with .45-caliber solutions.

Each outfit was run as a business, with staffs for sales, marketing, bookkeeping, transport and management. But there was one difference: every one also had a political department to furnish bribes to an enormous number of public employees. City police and their chiefs, mayors and their aldermen, revenue agents, FBI agents, customs agents, state policemen and their officers, judges, prosecutors, coastguardsmen—everybody was on the take.

It was possible because despite the utmost efforts of the Temperance lobby, Prohibition was massively unpopular. Thus it was not seen as a crime to help provide a commodity the public desired. Or as the biggest, baddest bootlegger of all, Al Capone, said, "I make my money by supplying a popular demand. If I break the law, my customers are as guilty as I am. When I sell liquor, it's bootlegging. When my patrons serve it on silver trays on Lake Shore Drive, it's hospitality."

The impact of Prohibition on Florida was immense. Capone came to Miami from Chicago and bought property. He often returned on vacation.

Top public officials became enmeshed in corruption. The public at large seemed to favor rum over the law.

What Eliot Ness was to Chicago, Colonel L.C. Nutt tried to be in Miami. Nutt came to town in 1922, heading an anti-smuggling task force of navy ships and aircraft, coast guard boats, undercover cops and federal prosecutors. After weeks of investigation, on March 20, 1922, Nutt sent eight squads on surprise raids that proved not very surprising. John Rothchild, in *Up For Grabs*, describes what happened:

> *The real surprise was that the Nutt forces nabbed anybody; they only managed to arrest 20 people. 'Prohi Raids Prove Failure,' the* [Miami] Herald *headline said. Those arrested were not overly concerned even then—the entire federal effort on land, sea and air resulted in six convictions. The* New York Times *reported that Col. Nutt retreated from Miami: 'before he was laughed out of the state but not before the snickers were audible.'*

The forces of law and order pressed ahead. In South Jacksonville, virtually the entire city administration—the mayor, the chief of police, the president of the city council, the city commissioners and the fire chief—was indicted by a federal grand jury for Prohibition-related activity.

In Fort Lauderdale, nineteen people, including the sheriff, the assistant chief of police and seventeen policemen and deputy sheriffs, were arrested on charges of conspiracy.

And in Tampa, one retired policeman told Alduino in an interview, "Bootleggers made no bones of their business, smiled when arrested, paid up immediately, and continued to defy authorities."

Two small but important footnotes must be added to the rumrunner story. The smugglers used the new medium of radio in their enterprise, and the U.S. Coast Guard set up radio interception stations in New York City, San Francisco and Florida in 1927. The rumrunners were already aware radio broadcasts could be overheard, so they began using codes and cryptography. Elizabeth Friedman was hired as a code breaker. Although the code breakers went through many bureaucratic evolutions, she and the coast guard were the genesis of the National Security Agency (NSA or "no such agency") that became the nation's official multibillion-dollar home for eavesdroppers and code breakers.

The second addendum concerns the use of aircraft. The First World War jump-started the "world of flight" by training large numbers of pilots and producing large numbers of aircraft. Smugglers were among the first to make commercial use of the new transport. Across both the Florida Straits

and the U.S.–Mexican borders, aerial smugglers contributed to the flow. It is another example of smuggler innovation—air freight.

The first Florida land boom was just beginning when the early rumrunners set sail. As John Rothchild so vividly describes, the two activities were soon linked.

National Prohibition was imposed at the beginning of the Florida boom. Miami was a mud town, and less than ten years connected it to the nation via Flagler's train. With no industry to which the virtues of pluck and luck applied, the model for economics was real estate, and land had gone from $10 an acre to $10,000 an acre in a matter of months. The only substance besides land that offered a similar return was illegal liquor, which first sold for less than $10 a quart, and then rose to more than $100 a quart, diluted.

Aircraft were still a novelty during Prohibition. That did not prevent their use in smuggling. In this undated photograph we find Customs Officer W.B. Evans with an aircraft and automobile he seized as the driver and pilot were in the process of transferring six kegs of bootleg whiskey. *Courtesy Library of Congress.*

By modern standards, the illicit Miami booze trade was pedestrian, compared to what was to come sixty years later, when new mother ships and faster speedboats would again dominate headlines. The 1920s were a time of wild growth, as the first Florida land boom was fueled with money from the alcohol trade. The land boom wilted after a 1924 hurricane, and withered after another hurricane in 1928. When Prohibition ended in 1934, the land boom had already collapsed, as had the national economy and the public's faith in its leaders.

As Asbury wrote, "It must be remembered, however, that the fourteen years from 1920 to 1934 were not only the era of unparalleled crime and corruption; they were also the era of the Big Lie. The drys lied to make prohibition look good; the wets lied to make it look bad; the government officials lied to make themselves look good and to frighten Congress into giving them more money to spend; and the politicians lied through force of habit."

It would take another wave of smuggling to pick the Florida economy back up and propel it to new heights. And greater lies.

WHATEVER YOU WANT

Smuggling is driven by wants and needs. The Confederacy needed guns to stay alive, and the speakeasies needed booze to stay in business. But less compelling products are smuggled too, supplying smaller markets with items craved by willing buyers.

People hunger after the craziest stuff but do not have the courage or skill to smuggle it themselves. So they either commission someone or go searching for someone in the business of handling smuggled goods. A person seeking an exotic antiquity might go to a gallery with a shady reputation, for example. A Cuban cigar fan may know of a "special" tobacconist.

Keeping illegal stuff out of the country is the job of several federal agencies. In the "old days," the border patrol patrolled the border, the customs service checked your luggage and the immigration people stamped your passport. It's not that easy anymore.

Following the attacks on the World Trade Center and Pentagon in 2001, a great reshuffling of bureaucratic deck chairs occurred when the cabinet-level Department of Homeland Security was created.

The lead investigative agency is new, a combination of elements from several older organizations. It is called the U.S. Immigration and Customs Enforcement, or ICE for short. It was formed in March 2003 as the investigative arm of the Department of Homeland Security. It combines elements of the former U.S. Customs Service, the Immigration and Naturalization Service and the U.S. Federal Protective Service. ICE is akin to the FBI; you won't see them until you are in deep trouble.

Other deck chairs were moved around too. For example, the CBP—the U.S. Customs and Border Protection Bureau—was created from elements of the Department of Agriculture, the Immigration and Naturalization Service, the U.S. Border Patrol and U.S. Customs Service. These are the uniformed officers checking luggage, stamping passports and patrolling borders. The U.S. Coast Guard (USCG) was taken away

from the Treasury Department and also put under the Department of Homeland Security.

In other words, the guns-and-glory guys went to ICE. The do-it-everyday guys are in the CBP. And the "Coasties" changed bosses too. While the deck chairs were rearranged, the major mission remained the same: stopping contraband.

For some desires, no store is convenient. Embargos, quotas and prohibitions add to exclusivity. Below are recent examples of people caught by ICE, the CBP and USCG, and are typical of the new breed of Florida smugglers. Some operate for their own benefit, while others feed a national supply chain. If the item of desire is on the "forbidden list," it must be smuggled. What follows is a potpourri of the crazy things people want so bad, they're willing to risk jail to possess them.

MISTRESS OF THE SKULL

A macabre 2006 incident shows the thin line between smuggling and legal international travel. Reuters news agency reported the CBP arrested a woman at the Fort Lauderdale airport on February 10 after finding a human head in her baggage but not on her customs declaration form. Oddly, it's not illegal to travel with a human head in your luggage, so she was charged with "transporting hazardous material" because the skull still retained "organic material." After a quick visit to the statute books, a second felony charge was filed, since she did not list the head on her customs declaration form. That made it smuggling.

Florida resident Myrlene Severe—a Haitian citizen—faced five years in prison on each count. Bond was set at $10,000, which she posted.

"Severe stated that she had obtained the package, which contained the human head, from a male in Haiti for use as a part of her voodoo beliefs," the U.S. attorney for the Southern District of Florida said in a statement reported by Reuters. "Severe also stated that the purpose of the package was to ward off evil spirits."

Affidavits filed in the case indicated the skull, with black curly hair, was in a cotton rice bag along with a banana leaf, dirt, small stones and a rusty iron nail. Broward County Medical Examiner Dr. Joshua Perper determined the skull was from a black man about forty years old or younger who had been dead more than a year.

After a look at federal regulations, prosecutors added an additional charge for attempting to import a human head "without proper documentation." Severe reached a deal with prosecutors to avoid fifteen years in prison and

pled guilty to a misdemeanor for "improper storage of human remains." The fate of the skull is unknown.

Dave Barry, the irrepressible *Miami Herald* humorist, asked what all the excitement was about. It was just, he wrote, "carrion luggage."

COUNTERFEIT CIGARS

The smuggling connection between Florida and Cuba is centuries old. Today's contraband is cigars, the famed Cuban Cohibas, Partigas and other legendary brands. They are forbidden because of the trade embargo placed on Cuba in 1962 by President John Kennedy.

Kennedy's press secretary at the time, Pierre Salinger, told an anecdote about the imposition of the embargo. In the Oval Office, Kennedy asked, "Pierre, did you get those boxes for me?"

"Yes, Mr. President. 1,100 Cuban cigars."

"Excellent," said Kennedy. He then reached into his pocket, pulled out a pen and signed the embargo.

The law smugglers violate is much older than the Cuban embargo. It is the Trading with the Enemy Act of 1917, giving the president the power to restrict trade with America's foes.

Only Cuba, Iran and North Korea are under embargo today. While there is no demand for North Korean goods, there is lively interest in fine Cuban tobacco. Demand is so strong that a flourishing trade in smuggled cigars is well established. Unfortunately, demand is so strong smugglers are shipping counterfeits in addition to "the real McCoy."

The economics are simple. Cuba is a communist state with a demand economy. Production of bona fide Cuban cigars is tightly controlled to keep prices high. While styles and sizes of cigars vary enormously, a box of the genuine article from a government-licensed store in Havana costs $400 or much more.

Every cab driver in Havana will offer you a box of "genuine Cubans" for much less. The box will look authentic, and unless you are a true connoisseur of fine tobacco, the smoke will be robust and tasty. But not nearly as robust and tasty as the real thing. Your cab driver may charge you only $50 per box. Or maybe even $200, depending on how much of a sucker you appear to be.

The Cuban economy resides mostly "underground," and the cigar business is no exception. Furniture makers also make authentic-looking cigar boxes. Printers make labels. Men, women and children across the island roll counterfeit Cuban cigars using inferior filler and wrapper tobacco every day.

A pensioner receiving twenty dollars per month can roll two hundred cigars a day, enough to fill ten boxes. Paid a dime apiece, the pensioner has doubled his or her monthly income in a day. It is estimated that only about 10 percent of Cuban cigars on the world market are authentic.

Because the United States is the only nation with an economic embargo against Cuba, nationals of any other country can visit the island and return home with boxes of "real Cuban cigars." These can be wholesaled to local tobacconists well below the rate charged by the Cuban government's authorized distributors. The "bootlegs" are then resold at retail to the public for a significant premium but still below the price at the Cuban-authorized shops. In the United States, the trade is totally underground.

While Cuban law prohibits tourists from exporting more than seven boxes, the authorities (who also live on a pittance) are usually agreeable—for a gratuity—to overlook a tourist's ignorance of Cuban export law.

The Cuban government turns a blind eye to the practice because it doesn't affect the prices it charges for the authentic product. And the counterfeiting and smuggling operation pumps badly needed hard currency into the black market, which eventually winds up back in the government's coffers. And it expands Cuba's tobacco industry. Everybody wins but the ultimate smoker-consumer.

The U.S.-Florida smuggling of cigars is not immune from the counterfeit trade. Only an experienced smoker can tell the difference between the counterfeit and real article—both are made from Cuban tobacco, after all. The real issue is prestige, not the color of the ash (the tip-off: a legitimate, state-approved Cuban has a darker ash, not bone white).

The U.S. Department of Homeland Security takes a dim view of Cuban cigar smuggling, real or fake. While most smugglers simply see their cargo confiscated, occasionally a smuggler will take a hard fall and end up in prison.

In June 2002, Richard Connors, a Chicago lawyer, received thirty-seven months in federal prison for his cigar-smuggling efforts. He had traveled regularly to Havana since 1996. From press reports based on court documents, Connors was buying fakes and selling at real prices. The Associated Press reported witnesses said, "Connors went to Cuba by way of Canada and Mexico almost monthly, bought cigars and brought them home with him. They testified that he bought cigars at $25 to $60 a box and sold them in the United States for up to $400 a box."

Conners could have saved his travel budget by flying to Florida instead. Both fakes and the real thing are readily available if arrests in the mid-1990s are any indication.

In August 1995, the coast guard stopped a powerboat heading to Fort Lauderdale from the Bahamas. It was carrying 122 boxes. The same month,

Richard Sperandio was busted in Key West while unloading his boat. He told authorities he bought 104 boxes at Marina Hemingway, the yacht harbor just west of Havana. He said he paid $3,600 ($36/box) and planned to sell them for $28,000 ($250/box). He received a year's probation and 50 hours of community service.

In May 1996, two Bahamians successfully smuggled almost 3,000 Cuban cigars in their luggage through Miami International Airport and began selling them around the city. A Miami hotelier tipped police, who found 114 boxes in their room. They were deported. One month later, a Miami man was arrested in Arizona for selling 2,000 Cuban cigars. He entered the country at Miami International and the cigars were shipped across the country.

David Adams, in the *St. Petersburg Times* on May 6, 1997, wrote about the reception two men received when they tied up at Marina Hemingway near Havana: "According to court papers, one of those arrested, a Beverly Hills BMW dealer, said that sales people just showed up on the dock in Cuba, bearing catalogs touting Cohibas, Montecristos and other prized cigars. He told the agents he bought them thinking they would make fine gifts for his customers." The men were carrying 49 boxes containing 1,296 cigars hidden in closets and below deck in the bilge area.

Authorities say the odds of you being offered a bona fide Cuban cigar—at Marina Hemingway or your favorite cigar bar, tobacconist or upscale restaurant—are minimal because the counterfeits have proliferated like wildfire. To buy "the real McCoy," Americans have three choices: smuggle the cigars from Cuba personally and buy only from a government store. Or you can go to a tobacconist (in another country, of course) authorized by the Cuban government and be prepared to pay staggering prices. Then you still have the problem of smuggling them back into the United States.

Or you can buy on the American black market and take your chances somebody hasn't relabeled a $20 box of Hav-A-Tampas into $1,200 worth of Cohiba Sublimes. The website for CubanBest Cigars in Vancouver, British Columbia, offers a few suggestions on spotting fakes: "Smugglers are only interested in making money, and the preferred method is to buy boxes of counterfeit cigars for $25–50 and then resell them in the States for $400. Or another popular method, done from within the U.S., is to take bundled non-Cuban cigars, slap on a counterfeit label, box them up and sell them as the real deal," someone named "Rod" wrote on the store's website. He continued:

Try to buy from a tobacconist who has an authorized Habanos sticker in the shop window. Check for the warranty seal—the Cuban

tax/seal stamp is applied to all boxes of Cuban cigars. In early 2000 an updated warranty seal started to appear. The new seal is on all boxes since 2000, so if the box was made before 2000, old seal—after 2000, new seal. The major differences between the two seals is easily seen—the new seal has a set of serial numbers in red lettering. Also, the new seal has only 5 field workers in the little oval picture. The old seal has no serial numbers and there are nine field workers in the oval picture.

As for the box itself, Ron advised checking the bottom for three notations: "Habanos s.a.—the s.a. is in small letters, not capitalized. HECHO EN CUBA—all capitalized encircled by a straight-sided oval. *Totalmente a mano*—written in script." Top-notch smugglers know all this, of course.

Not only is the profit margin huge for both the smuggler and reseller—real or fake—but some are not smuggled at all. They're produced in the United States, with forged bands and boxes. There are enough authentic Cuban cigars in circulation that counterfeiters have wonderful models from which to draw.

Smuggling Cuban cigars into Florida predates Communism. After the American Civil War, liquor and cigars were smuggled frequently into west coast ports like Cedar Key, St. Marks and Tampa to avoid customs duties.

The contraband came aboard regularly scheduled steamships operating between Key West and Havana. Often the smugglers were the same people who ran the blockade into the Confederacy. "The opportunity to make a few extra dollars by smuggling on their return trips from Cuba was not regarded as a serious infraction by those engaged in it, or even by most of their neighbors," Jerrell Shofner wrote in his article "Smuggling Along the Gulf Coast of Florida During Reconstruction" in the *Journal of the Tampa Historical Society.*

OPERATION MAGIC CARPET

Iran too is under embargo. We don't buy their oil (officially), but we still buy their (smuggled) rugs.

The rug holds a special place in Muslim culture. It is an object used in devotion, it is used to floor the tents of Bedouins and it is used to floor the palaces of pashas.

Rugs are found in mosques and in museums too. The craftsmanship of rug fragments four hundred years old continue to be admired. With proper conservation, a "good rug" will last for generations and centuries.

To learn about rugs requires patience and visits to many shops to see and feel any number of carpets. An appetite for hot sweet tea will be acquired too. Knots per inch, and which knot? Natural or artificial dyes, cotton, wool or silk, new or antique? The answers to these questions create connoisseurship among the rug cognoscenti and yet one more area of specialization for customs officials.

While every rug-making country praises its product, there is always grudging admiration for the Iranians. Coupled with an embargo, you should know what that means: smugglers are afoot.

The term "Operation Magic Carpet" has had many uses, from post–World War II demobilization to an Israeli airlift of Jews from Yemen in 1949. Today's Operation Magic Carpet is shrouded in deep secrecy.

Our only information comes from the U.S. Treasury Department's *Office of Inspector General semiannual report, October 1, 1994—March 31, 1995.* The executive summary says:

> *On January 3, 1995, an individual who was not a Customs employee was arrested in Toronto, Canada, by the Royal Canadian Mounted Police in cooperation with Customs' Office of Internal Affairs and Customs' Office of Investigations. In August 1994, the individual had paid a $25,000 bribe to an undercover Customs special agent for the illegal release of a seized shipment of Iranian rugs worth approximately $1 million. As part of a public corruption, smuggling, and fraud conspiracy undercover operation referred to as "Operation Magic Carpet," the Office of Internal Affairs, the Office of Investigations, and Inspection and Control investigated the smuggling and fraudulent entry of prohibited Iranian carpets via bribery and false documents.*

The document contains many more cases under investigation, and deep inside it says: "'Operation Magic Carpet' was terminated on November 18, 1994, with the arrest of an alleged carpet smuggler from Miami, Florida, who between December 1993 and November 1994 paid nearly $70,000 in bribes to allow Iranian origin goods to enter the United States or be released from customs seizure. The undercover operation was initiated after a supervisory customs inspector informed the Office of Internal Affairs and the Office of Investigations that the alleged carpet smuggler had made a bribe overture in December 1993."

The name of the smuggler and the disposition of the case are unknown. Nor is there word of who received the $70,000 bribe or what happened to them. We do know for at least a year Mr. Rug Merchant was able to move

his merchandise (at least a million dollars worth) into the American market. Did he sell those rugs in Miami?

HOT COINS AND OLD STATUES

In 1994 a Key West man found ancient coins while scuba diving on a shipwreck in the Red Sea between Africa and Saudi Arabia. It was more than pocket change; it was 132 pounds of ancient coins. Somehow he brought them back to the United States. And then didn't know what to do with them.

He researched the coins through the Internet and realized maybe they were more valuable than he thought. Then he started making careful inquiries in numismatic chat rooms to determine if coin collectors might be interested in some of his unusual examples. His caution seemed to indicate he knew possession of his hoard wasn't kosher.

He wasn't discrete enough, though. Somebody tipped ICE agents, who expressed interest via e-mail in seeing some of the coins in person. The items matched a red notice posted by the Saudi government to Interpol. When the ICE agents rendezvoused with the coin finder in April 2005, they identified themselves and the coin finder surrendered his stash.

The coins were administratively forfeited and returned to the Saudi government on March 6, 2006. An ICE press release said, "'These coins are treasured artifacts that reflect the cultural heritage of humanity as well as Saudi Arabia's unique history as an ancient trade center and as the birthplace of Islam,' said Saudi Ambassador Prince Turki Al-Faisal. 'Their recovery and return to the Kingdom is an example of the deep friendship between Saudi Arabia and the United States and the respect the U.S. has for cultural heritage.'"

In another after-the-fact seizure of smuggled goods, while serving search warrants in September 2005, agents found 322 pre-Columbian artifacts, including one that was 3,500 years old. The raids followed a two-month joint investigation by ICE and the Broward County Sheriff's Office. One man was arrested.

The artifacts include pottery figurines, burial shrouds and gold jewelry from the Inca and pre-Incan civilizations of Peru. They were examined and authenticated by an art historian at Florida International University. The seizure is one of the largest ever for pre-Columbian works of art. One of the textiles is believed to be a burial shroud linked to ancient Peruvian royalty. The items were returned to the Peruvian government.

It's small enough to put you in jail. And big enough to create an Interpol case. This coin was among 132 pounds of coins found in the Red Sea by a Florida resident. A sting by Immigration and Customs Enforcement sent the coins back to Saudi Arabia and the Floridian into federal custody. *Courtesy Immigrations and Customs Enforcement.*

Again, more thankful words in an ICE press release: "The Peruvian government views with high regard these recoveries of the World Cultural Heritage, in this specific case of artifacts from early Peruvian civilizations," said Jorge E. Roman, consul general of Peru in Miami.

Smuggling of antiquities is a well-established practice worldwide. Many countries today are trying to reacquire these antiquities as part of their national patrimony. As these two cases show, federal and local agents are involved in helping find and return antiquities. Even though they were smuggled into the country successfully, the taint of the smuggler doesn't wear off with time.

NEW THREADS, BAD THINKING

Florida Governor Jeb Bush, brother of President George W. Bush, had a personal brush with smuggling in 1999. Customs agents in Atlanta busted his wife Columba for not declaring $19,000 in new clothes and jewelry she had bought in Paris. It was Jeb's first year on the job and not a shining family moment.

Customs officials said she put $500 on her declaration form, but they found receipts in her purse for more. So they searched her luggage, and indeed she'd bought twenty-eight times $500 worth of fancy stuff. The fine was $4,100, triple the duty she would have paid if she had declared it.

Why would a Florida governor's wife tempt fate by smuggling? It's not the usual story. Jo Becker with the *St. Petersburg Times* reported on June 22, 1999: "Gov. Jeb Bush said Monday that his wife misled U.S. Customs officials about $19,000 in new clothing and jewelry she brought into the country because she didn't want him to know how much she had spent on her five-day Paris shopping trip."

Challenged by authorities, Columba Bush was stubborn about it. "Customs agents then found some shopping receipts in her purse. But Mrs. Bush declined the opportunity to change her declaration, Customs spokesman Patrick Jones said. After that, customs agents searched her luggage and found the merchandise. At that point Mrs. Bush confessed to all of her purchases, telling agents she did not answer truthfully at first because she did not want her husband to know how much she had spent, according to Bush spokesman Cory Tilley," Becker reported. Governor Bush promised his wife a Paris vacation after the 1998 Florida gubernatorial campaign. He got more than he bargained for, in more ways than one.

She was allowed to keep the clothes and jewelry, the usual practice when fines are paid. When I say, "Everybody's a smuggler in Florida," I'm not kidding.

NIGHTMARE ON NOAH'S ARK

S mugglers have yet another acronym to fear: the "Effen W"—the U.S. Fish and Wildlife Service. In the 1990s, this organization launched a series of ingenious undercover operations to halt the illegal trade in endangered plants and animals. If you are hungry for jaguar fangs, staghorn coral or Australian cockatoos, these are the people to watch out for.

The F&W history begins in 1885, with the creation of the Division of Economic Ornithology in the Department of Agriculture. Among other tasks, it studied the flight paths of migratory birds and their impact on agriculture. The division expanded and in 1905 was renamed the Bureau of Biological Survey.

In 1900 Iowa Congressman John Lacey introduced and passed an act of Congress aimed at preserving game and wild birds. The Lacey Act prevented hunting them (or collecting their eggs) in one state and selling them in another. Since then the law has been amended significantly to expand not only its penalties, but also the variety of plants and animals protected. Its reach is now global. But defiance of the rules is still a Lacey Act violation.

In 1934 the Biological Survey received a new chief when President Franklin Roosevelt appointed Jay "Ding" Darling to run the operation. Today the appointment would be highly controversial because Darling was a nationally syndicated editorial cartoonist with a very pro-environment attitude. He won the Pulitzer Prize twice (1924 and 1942) for his drawings. Darling ran the Biological Survey for two years before returning to Iowa and his drawing board. It was a short tenure with long implications. He vastly increased the acreage in the National Wildlife Refuge system; he implemented the National Duck Stamp program, required by all duck hunters; and he designed the wildlife refuge logo still in use.

In 1934 the Duck Stamp Act was passed and Darling designed the first stamp himself. The stamp is a federal license to hunt waterfowl and to date has generated $670 million, of which 98 percent has been spent acquiring waterfowl habitat for inclusion into the National Wildlife Refuge program. Darling left the Biological Survey in 1935. Residents of Sanibel Island are familiar with the name Jay "Ding" Darling; the large wildlife preserve on that island is named after him.

The Fish and Wildlife Service—the "Effen W"—was created in 1939 by combining the Biological Survey with the Bureau of Fisheries. In 1973 Congress passed the Endangered Species Act with F&W as the enforcement arm.

The same year, also in Washington, representatives of 80 nations gathered to sign another document—the Convention on International Trade in Endangered Species of Wild Fauna and Flora. The acronym is CITES (pronounced site-eze). It entered into force in 1975. Today 169 nations are members.

The CITES secretariat reports to the United Nations Environmental Program. It is also party to a number of memorandums of understanding with Interpol, the World Customs Organization, country-specific organizations (such as U.S. Fish and Wildlife) and the nongovernmental organization TRAFFIC, which monitors trade in endangered species for the World Wildlife Fund.

The CITES document has three appendixes. Appendix I lists the most endangered species. Any species transferred out of its wild home must be accompanied by an export permit and an import permit, and is allowed only "under exceptional circumstances." On Appendix I, listed as endangered are 827 species, 52 subspecies and 19 populations.

Appendix II lists species that are "not necessarily now threatened with extinction but that may become so unless trade is closely controlled." That list includes 32,540 species, 49 subspecies and 25 populations.

Appendix III is a list of species included at the request of any CITES signatory already regulating trade in a species that needs the cooperation of other countries to prevent unsustainable or illegal exploitation. On Appendix III, 291 species, 12 subspecies and 2 populations appear.

A violation of CITES in America is a Lacey Act violation under United States law. The U.S. Fish and Wildlife Service is the agency empowered to go hunting for wildlife smugglers.

Congressman Lacey was concerned about interstate transport of birds more than a century ago. The trade in contraband wildlife is at least that old. The law bearing his name enforces America's international fight against the trafficking of all endangered species. Possession of long-dead relics of

the species—the old fangs of a jaguar or a particular breed of tortoise shell—can put you in jail, even if you inherited it, if you try to move it across a border. Museums, for example, require a CITES permit when they dispatch a traveling exhibition containing forbidden feathers, fangs and shells to another museum abroad.

Violation of the CITES treaty by importing and exporting endangered plants and animals is a huge business. An Associated Press report in May 2006 by John Heilprin said, "The United States and China are the biggest markets for an estimated $10 billion global trade in illegal wildlife. The black market in wildlife and wildlife parts is second only to trafficking in arms and drugs."

CITES created not only a new role for the Fish and Wildlife Service, it also created a new type of contraband. And where there is contraband, there will be smugglers.

BLACK MARKET, BLACK CAVIAR

One Florida-based smuggling operation had roots in the Caspian Sea area, where people fish for sturgeon. The contraband is its caviar. Long a favorite appetizer of the rich and royal, caviar is the salted eggs of an ancient fish species. It takes about twenty years for a sturgeon to reach sexual maturity and ovulate. Harvesting for roe kills the fish.

Connoisseurs favor caviar from the Beluga sturgeon of the Caspian Sea, bordered by Iran and Russia. After the 1917 revolution, the Soviet Union began tightly regulating sturgeon fishing to prevent depletion or destruction of the fish population.

Moscow set up two Russian émigré brothers in the caviar business in Paris in the 1920s. Petrossian Paris became the primary conduit for Russian caviar to the west, the holy-of-holies for the caviar connoisseur. When the Soviet Union collapsed, the enforcement of controls on production and export of caviar evaporated. Caspian Sea fishermen became poachers under the wing of the emerging Russian mafia, which created a clever smuggling market based in Poland. Production soared.

While increased caviar production was good for food snobs, it was a disaster for the fish. In a short time, sturgeon stocks plummeted.

In 1998 sturgeon was added to the list of animals protected under CITES. Under the new rules, caviar now required a valid foreign export permit issued by the country of origin, or a valid foreign reexport certificate issued by the country of reexport. These rules opened a huge market for smuggled caviar.

Victor Tsimbal, a forty-two-year-old Russian citizen living in Miami, was the owner of Beluga Caviar, Inc. Instead of being forced out of business by the CITES requirements, Tsimbal found an economic opportunity.

He capitalized on his existing supplier network, now taken over by the Russian mafia. In addition Tsimbal recruited individuals in Miami to smuggle caviar from Poland, offering airplane tickets, hotel accommodations and $500 per trip to his mules—civilians recruited into smuggling. The mules viewed it as a free European vacation.

In Poland they received prepackaged suitcases full of Beluga caviar from the Russian mafia. The Polish hand-over kept the smuggler's passports untainted by stamps from Iran, Russia or any of the new nations (called "the –stans") created after the fall of the Soviet Union. Poland's president was eventually implicated in the scandal.

Even at $1,000 per pound, caviar remained in high demand in South Florida. Tsimbal approached Optimus, Inc., a Miami-based company operating Markey's Caviar and the International Food Emporium. Tsimbal was not their only supplier. Optimus was using the services of four other caviar smuggling rings to feed the demand.

Tsimbal decided to diversify his clients but blundered into the cops. A search warrant turned up $500,000 worth of caviar at his business, and a trail that led to Optimus. A Department of Justice press release on August 26, 2002, gave an idea of the magnitude of Tsimbal's activity: "Tsimbal admitted to using false documents to smuggle more Beluga caviar from Russia into the United States via Poland in 1999 than the entire Russian export quota for the year, according to a detailed factual statement filed in court."

But that was nothing compared to Optimus. It was charged with the illegal import of 5.9 tons of caviar, worth nearly $12 million on the retail market. That's a lot of fish eggs.

On June 2, 2002, Tsimbal pled guilty to conspiracy, smuggling and money laundering. He received a forty-one-month prison sentence and forfeited the $36,000 he was carrying when he was arrested at Miami International Airport. He was the ninth individual convicted of caviar smuggling in Miami in a two-year period.

As for Optimus, it also pled guilty as a corporation, agreed to pay a $1 million fine and promised to comply with all appropriate regulations in the future.

In June 2001, the United Nations organization enforcing CITES declared a total worldwide ban on the trade of caviar. Eve Vega with Petrossian Paris told the *London Telegraph*, "That is a disaster. Totally banning the trade, rather than taking the more difficult route of properly policed protection,

simply hands the whole industry over to the bandits. It is now Prohibition and Al Capone." Eight months later, after Russia, Azerbaijan, Kazakhstan and Turkmenistan agreed to reduced quotas, trade was allowed to resume.

In 2003, nearly a ton of caviar (worth nearly $2 million) arrived at the Port of Miami from Kazakhstan. Was it Beluga caviar? Federal wildlife inspectors put the load in cold storage and tested the caviar to determine if it came from a CITES-listed species. Tests indicated the slaughtered sturgeon from which the caviar was produced were not on the CITES list. But six months later, the Kazakh company agreed to donate $90,000 to the National Fish and Wildlife Foundation and ship the caviar back to Kazakhstan.

In January 2006, the secretariat of CITES banned the international trade of all caviar by refusing to approve any quotas until producing nations could develop a plan to ensure the survival of their sturgeon stocks.

On June 30, 2006, the European Union hosted an international meeting to discuss methods of caviar control. The monitoring organization TRAFFIC reported on its website:

The participants agreed on a set of rigorous measures to improve the exchange of intelligence and co-ordination, undertake joint international investigations and to implement measures such as the universal labeling system for caviar. Other measures included the registration and licensing of all caviar processing, re-packaging and trading businesses in order to ensure that only legal caviar is filtering through to markets, to step up controls of any suspicious caviar trader and closely monitor smuggling routes and to make more widespread use of DNA tests that can help to identify the origin and source of the caviar and thereby detect fraud and mis-declaration.

The European Union is the world's largest consumer of caviar. It sponsored the meeting, which included all producer countries. The only legal caviar at this writing comes from existing legal stockpiles or sturgeon "farmed" in aquaculture facilities.

ONE HOT LADY-SLIPPER

The last place you would expect a federal raid is the Marie Selby Botanical Gardens in Sarasota, Florida. The gardens are lush with tropical foliage and the organization is world famous for its orchids. So when Michael Kovach showed up with a gorgeous, previously unknown specimen and offered it for identification, the gardens were grateful for the opportunity.

Kovach, a Virginia orchid collector, found the plant at a roadside stand in the Peruvian Andes. He'd never seen anything like it, with its hand-sized blossom of pink shading into purple. He bought three for $3.60, and gave two of them to a friend. The third he offered to Selby on June 4, 2002.

It was a member of the lady-slipper family but a new species. In a press release, the gardens hailed it as the most important orchid discovery of the last one hundred years. The little celebrity needed a name so it was dubbed *Phragmipedium kovachii* in honor of its discoverer and a description was rushed into print. It was a new "frag" (to use the slang name of the genus).

Wild orchids are protected under the CITES treaty, which bans collection of endangered plants in the wild. Only plants grown in nurseries or laboratories can be sold. And lady-slippers—the "frags"—are on Appendix I, the most endangered species list of CITES.

The orchid world is very small, and news travels both far and fast in these electronic times. The Peruvian government complained and quicker than you can say *Phragmipedium kovachii*, federal agents conducted their first-ever raid on a botanical garden—on the trail of a hot orchid.

After a further year of investigation, a federal grand jury indicted Kovach, Selby Gardens and one of the garden's orchid experts, Wesley Higgins, for various felonies. The three pled guilty to misdemeanor possession. Higgins received two years' probation and a $2,000 fine. Kovach received two years' probation and a $1,000 fine. The gardens received three years' probation and paid a $5,000 fine, the first American botanical garden to admit violating CITES. The garden was required to take a full-page ad in an orchid magazine to apologize for its part in the lady-slipper caper. And further, the judge required the gardens to petition the international body responsible for naming new species to revoke the name *Phragmipedium kovachii*. Oddly, that's unlikely. Today you can view two pages of "frag" blossoms on Google Images. It's become a hot flower in the hothouse orchid world.

The notoriety of the Selby case—reported worldwide—did not stem the tide of orchid smugglers. Manuel Arias-Silver, a well-known Peruvian orchid exporter, was arrested at Miami International Airport in 2004 for trying to smuggle more lady-slippers into Florida. The indictment alleged Arias-Silver had been moving the flowers for more than two years through Miami to George and Kathy Norris of Spring, Texas, who resold them to others for high-end prices.

A search warrant in Texas turned up years of correspondence between Arias-Silver and the Norris family. One letter—the *Miami Herald* reported on March 6, 2004—urged shipment through Miami: "Miami is so overloaded with plant shipments that they rarely open boxes and do not look at many

plants. Make sure they are wrapped with moss and paper and in plastic as marked as Maxilliarias as before."

HERE, LUCKY BIRD

Florida's first known export was a bird—a red cardinal—which was considered good luck by the early Spanish sailors. There are very early reports of Native Americans from Florida selling cardinals to sailors in Havana. Today the trade moves in the other direction and it is grim. Not since slavers plied the ocean has one faction of smugglers been so indifferent to loss of life in transit. They are today's smugglers of birds.

Miami and Los Angeles are the two main ports of entry for birds. Parrots come from the jungles of Africa and South America, cockatoos come from the scrublands of Australia and some are tiny birds from Cuba.

Once birds are captured it's very difficult—most experts say impossible— to reintroduce them back into the wild. From an ecological point of view, it makes no difference whether the birds are killed or kidnapped. In either case, the removal from their native habitat is permanent.

The case of Adolph "Buzz" Pare, owner of the Gators of Miami pet shop, provides a window into the world of bird smuggling. His $300,000 fine and year in jail are the most stringent penalties given to a bird smuggler up to that time. But he was not the initial object of the investigation. It began in a ratty warehouse in Los Angeles, spread throughout the world and concluded with the conviction of one of the world's most famous parrot experts.

The lead investigator was Rick Leach, a fish and wildlife agent. He told interviewers for a PBS *Nova* documentary, "The Great Wildlife Heist," broadcast on April 11, 1997: "As it turned out, it involved some of the largest bird importation companies in the U.S., as well as some very complex smuggling schemes that were very difficult to detect, and the illegal activity here encompassed millions of dollars of smuggled birds."

Leach was assigned to check a tip from a California pet shop owner that birds smuggled in from Tijuana carried disease. He went undercover south of the border to check it out. A variety of vendors not only offered birds, but also told him how to smuggle them into the United States. Put it in a paper bag, they said, and put the bag in the trunk. In Tijuana's heat, it's easy to understand why many of the birds don't survive the trip.

Leach returned and consulted with colleagues. He then convinced his superiors to start a wide-ranging investigation of bird smuggling, which was dubbed Operation Renegade. The objective was not to bust the cross-border smugglers, but to find and prosecute the masterminds of the trade.

To do that, they decided to become part of the process. All birds entering the United States must undergo a thirty-day quarantine to check for disease. While these quarantine stations are inspected by the Department of Agriculture, they are owned by private individuals—often people in the pet business. So Leach found a quarantine station for sale and the government bought it. It was located in a gang-infested section of Los Angeles.

The previous owner of the station was Richard Furzer, a major importer of birds. He suggested to Leach that they should go to Africa and buy parrots. He even explained how to smuggle them.

The most popular parrot in America is the African Grey. It lives in the Congo and Zaire, and for whatever reason is the best "talker." Unlike other birds, Greys are robust, healthy and usually friendly. Pet shops can't stock enough of them.

Unfortunately the Republic of the Congo and Zaire forbid their export. So a minor industry developed, capturing African Grey parrots and transporting them to Senegal, Sierra Leone or the Ivory Coast, which have no export restrictions. The fact that these countries are outside the African Grey's natural habitat is a minor inconvenience, easily repaired with cash and fabricated documents. Call it "bird laundering."

In an interview, Furzer told *Nova*, "I was aware that the birds did not come from the Ivory Coast or Guinea, and to my mind, it didn't make any difference. They don't have border laws in west Africa like we do here, and they don't care where the birds came from, and I really didn't think that it was a crime. I realized that I was lying to the government, telling them the birds came from one country instead of another, but morally, it was fine by me."

Furzer and Leach imported millions of dollars worth of African Greys and other birds with questionable papers. By day, Leach would tend the birds in quarantine. By night, he would photograph and measure the birds, so wildlife officers and academic ornithologists could identify the species and probable country of origin.

These were the lucky birds, imported through the usual channels with official-looking documentation, although there were still losses in transit. Leach told *Nova*, "You would have 30 to 40 birds per shipping crate. I would always see a number of dead birds in shipments that came in. Dead birds was an inherent part of the wild bird trade. There's no way around it."

Birds smuggled by individuals across borders display a much higher mortality rate. Birds are often stuffed in a stocking or wrapped in tape to immobilize them. They are also stuffed inside PVC tubes cut with small slits for ventilation. These tubes can be arranged inside a suitcase.

Thomas Goldsmith, a veterinarian who worked with Operation Renegade, told *Nova*, "We see them coming in in suitcases here in Miami, or in the hulls of boats, and ridiculous numbers of them are dead, suffocated…If you are caught smuggling drugs, you do hard time. If you are caught smuggling animals, in most cases, they slap you on the wrist, they take away the animals. The worst cases that I've seen, six months, and it's worth the risk. And their profits are substantial. So there's a great impetus."

The investigation continued and spread to Australia, where smugglers were stealing eggs from bird nests because eggs were easier to smuggle than live birds. Australia prohibited the export of birds almost a half-century ago, yet a huge variety of Australian cockatoo species are available in pet stores worldwide. Everywhere Leach looked, the problem grew larger. Australian authorities were brought into the operation.

On January 16, 1992, federal agents sprung into action. More than thirty locations were raided including Buzz Pare's shop in Miami. A total of three hundred birds were taken into custody. The Australians rolled up their end of the net. Twenty-nine Americans were convicted, including Furzer, who received an eighteen-month sentence. Pare received a year in prison and a $300,000 fine.

Pare was considered the largest importer of African Greys in the United States. His indictment indicates he was responsible for bringing in more than four thousand "laundered" Greys from Sierra Leone and Senegal, buying them for about $85 apiece and selling them for $600 to $1,000.

Ronald Martinolich of Cocoa, Florida, was also ensnared in Operation Renegade. He was an egg smuggler, indicted for smuggling hundreds of cockatoo eggs from Australia. The eggs were hidden in vests worn underneath street clothing. Any egg that began to hatch on the long airplane trip between Australia and the United States was destroyed. Once delivered and hatched, each bird would bring between $1,500 and $12,500.

The biggest and most surprising catch was Tony Silva of Chicago. He began collecting birds at age nine and by sixteen, he was writing articles about them. He published his first bird book at age twenty. He went to South America, and began writing about the cruel trade of bird smuggling, how the birds were trapped and then transported clandestinely to American wholesalers, pet stores and individual collectors.

Although self-educated, he was considered a leading expert not only on the birds, but the dangers they face. In 1989, he wrote *A Monograph of Endangered Parrots* and in 1991, *Psittaculture: The Breeding, Rearing and Management of Parrots*.

At exactly the same time he was writing, he was smuggling, court documents allege:

Between 1986 and 1991, Mr. Silva conspired with Gila Daoud (his mother), Hector Ugalde, Gisela Caseres, and several unindicted co-conspirators (Horacio Cornejo, Larry Lafeber, Mario Trabaue and others) to smuggle protected parrots and macaws into the United States. Cornejo obtained many of these birds illegally in South American countries and sold them to Lafeber. Lafeber would then ship them to the United States. One of Cornejo's sources was Caseres, who smuggled the birds from Paraguay or Brazil to Argentina. The shipments of illegal birds were commingled with shipments of legal birds. Mr. Silva and Lafeber then separated the shipments at the quarantine station and removed the illegal birds while the United States Department of Agriculture employee was distracted. Mr. Silva then sold them to purchasers who were unaware that the birds had been imported illegally and had not been quarantined.

On January 30, 1996, Silva pled guilty to smuggling 450 rare and endangered birds into the United States, and selling them for nearly $1.4 million to well-heeled collectors. Later in the year, he was sentenced to nearly seven years in jail, and fined $100,000—one of the most severe penalties ever levied against an animal smuggler.

Silva tried to have his guilty plea withdrawn, and appealed to the U.S. Court of Appeals, Seventh Circuit. He claimed he was tricked into pleading guilty, and was the focus of a government conspiracy. On August 18, 1997, his appeal was denied.

The seminal organization of the fish and wildlife service—the Division of Economic Ornithology of 1885 —was America's first foray into fighting species extinction. It is noteworthy that its descendant is still on the front line of fowl preservation.

EVERY FEATHER COUNTS

The CITES treaty also forbids importation and trade in parts of endangered animals and plants, as Milan Hrabovsky found out when federal agents raided his business in Gainesville on March 12, 2003. The indictment said, "Rain Forest Crafts, Tribal Arts and Morpho Ventures sold handicrafts and other products containing parts of protected species of wildlife at markets and craft fairs throughout the U.S. and over the Internet." Hrabovsky was busted for selling feathers and teeth.

"The protected species included feathers from Blue and Yellow Macaws, Red and Green Macaws, Scarlet Macaws and Great Egrets. Court documents reveal these feathers as well as Jaguar teeth were used in Brazilian Indian ceremonial headdresses, masks and necklaces which Hrabovsky sold to a Special Agent of the U.S. Fish and Wildlife through the mail," court documents indicated.

Hrabovsky was indicted on 545 separate counts of smuggling and pled guilty to 17 felonies. He cooperated with investigators, who then arrested ten of Hrabovsky's biggest customers. They paid nearly $40,000 in fines. This seems to indicate that mere possession of forbidden feathers and fangs is a crime. Meanwhile Brazilian police rounded up eleven suppliers—all government employees of the National Indian Foundation.

On June 20, 2003, Hrabovsky was sentenced to forty months in federal prison. The evidence seized in the raid—hundreds of tribal headdresses, masks and ornaments—was added to the collection of the Florida Museum of Natural History.

"I NEED A GORILLA"

Just about every animal known to Noah has slipped through customs in Florida. But this anecdote almost defies belief with a combination of audacity and stupidity.

Miami animal dealer Mathew Block of Worldwide Primates was implicated in a Thailand case of smuggled apes and agreed to help U.S. prosecutors any way he could to avoid jail. So when Victor Bernal, director of zoos and parks for Mexico, approached Block and asked for a little illegal help, Block was delighted. Bernal said one of his gorillas had died in a Mexican zoo and he needed another. Could Block help?

The dealer was happy to introduce Bernal to "Señor Blanco," the undercover Fish and Wildlife Officer Jorge Picon. The sting was set in motion with a visit to gorillas at the Miami MetroZoo. Picon convinced Bernal the apes were actually his and on loan to the MetroZoo. Picon asked how many Bernal needed. One would be fine, a big one, Bernal said.

Bernal flew back to Mexico City to get authorization for the purchase. The price was $92,000. Meanwhile in Miami, Picon arranged the next part of the sting. A DC-3 was borrowed from customs, and parked at the Opa-Locka Airport. A cage was borrowed from the MetroZoo, complete with a stash of gorilla dung for ambiance. In the cage was Wildlife Officer Terry English, dressed in a shabby gorilla suit.

When Bernal arrived, it was dark. He peered inside the cage at "his gorilla." English thought he was getting too close and might smell a rat

(instead of the gorilla dung), so he jumped at the door and gave it a mighty thump with his forearm. Bernal jumped back and said, "That's a big one!"

At that point, another wildlife agent playing the role of pilot put Bernal under arrest. With that done, English—who was sweaty and itchy—opened the door to the cage and started climbing out. Bernal panicked, thinking the gorilla was going to attack him, and started to flee. Two more agents tackled him, and the trio turned to watch English pull the head off his costume. That was even more grotesque, as English had long hair and a beard, all matted with sweat. Bernal panicked again.

Picon's "Señor Blanco" persona—flashy cowboy boots of endangered leathers (from the evidence room) and a foul-mouthed Colombian accent— fooled more than Bernal. For decades, Picon's undercover work in south Florida led to the arrest and conviction of scores of CITES violators. He retired in 2004 as head of Miami enforcement of the U.S. Fish and Wildlife Service. As for Bernal, he received seventy days in jail.

REPTILES ON THE RUN

The case of Keng Liany "Anson" Wong gives insight into the universe of reptile smuggling. Although indicted for smuggling endangered Fiji iguanas, Bengal monitor lizards and Indian soft-shelled turtles into Florida in 1992, they didn't catch him. Wong continued to run his extensive reptile smuggling operation from his hideout in Penang, Malaysia.

While Wong was careful not to return to the United States after his indictment, in 1996 he began to deal with a reptile import-export business called PacRim Enterprises. It was actually another U.S. Fish and Wildlife Service sting operation, this one run by George Morrison.

On the heels of Leach's Operation Renegade, Morrison set up Operation Chameleon in 1993, using many of the same techniques. It quickly reeled in Wong. "Through phone calls and fax exchanges with Morrison, Wong negotiated deals that allegedly delivered illegally imported Komodo dragons, plowshare tortoises, Chinese alligators, radiated tortoises (all endangered species), and other prized exotic reptiles to PacRim. At one point, Wong boasted of his ability to secure any animal Morrison desired, saying, via fax, 'I can get anything here from anywhere. It only depends on how much certain people get paid. Tell me what you want, I will weigh the risks, and tell you how much it'll set you back,'" *U.S. Fish and Wildlife News* reported in its November/December 1998 newsletter.

Morrison wanted more and Wong agreed to meet face-to-face in Mexico City. When he arrived on September 14, 1998, he was arrested by Mexican

authorities and jailed. The United States pressed for extradition, but Wong fought it for two years from a Mexican jail before finally agreeing to come to the United States.

He pled guilty to forty felony counts on December 13, 2000. In all, Wong had made fourteen illegal shipments worth $500,000 to PacRim. He was sentenced the following June to seventy-one months in federal prison and to pay a $60,000 fine.

The roll call of Wong's smuggled inventory reads like a list of rare and endangered reptiles. The June 8, 2001 Department of Justice press release following his guilty plea noted,

> [The] *endangered species traded by Wong included two particularly rare reptiles from island nations. The Komodo dragon, the world's largest lizard, is native only to a relatively small area of Indonesia. The plowshare or Madagascan spurred tortoise, believed by many to be the rarest tortoise species, occurs only on the island of Madagascar, off the southeastern coast of Africa. These species bring particularly high prices on the black market. Both the Komodo dragon and the plowshare tortoise can each fetch up to about $30,000 in the illegal trade.*
>
> *Wong also trafficked in such rarities as the Chinese alligator (which inhabits the lower course of the Yangtze River); the false gavial (a crocodile whose range is restricted to parts of Indonesia, Malaysia, Singapore, and southern Thailand along the Perak River); and the radiated tortoise, another species found only on Madagascar. Black market prices for these endangered reptiles range from $5,000 to $15,000. Other species smuggled by Wong included Grey's monitor lizards, spider tortoises, Burmese star tortoises, Indian star tortoises, Boelen's pythons, Timor pythons, green tree pythons, and Fly River turtles.*

If nothing else, Operations Renegade and Chameleon made animal smugglers more careful about with whom they do business. While two "kingpins" were taken out of the picture, the $10-billion-per-year business in wildlife smuggling has not slacked.

HOT CORAL

By the close of the twentieth century, prosecutions based on CITES violations increased in number, severity and category. In 1999, for

the first time in American history, a person was sentenced to jail for smuggling coral.

Petros "Pete" Leventis received eighteen months in jail, served five years on probation and paid a $5,000 fine. His company was forced to pay a $25,000 fine for shipping protected corals and seashells from the Philippines. His Tarpon Springs-based gift shop, Greek Island Imports, brought in a variety of illegal corals, including the blue, organ-pipe, branch, brush, staghorn, finger, brown stem, mushroom and feather varieties—all on the CITES list. Some of the shells were illegal too: giant clams, China clams, bear's paw clams, helmet shells and trumpet shells.

When authorities inspected a forty-foot shipping container bound for Greek Island Imports in 1998, they found it contained four hundred boxes of shells and corals. Customs agents and the Fish and Wildlife Service backtracked the cargo to Esther Flores in the Philippines, who runs Esther Enterprises, a seashell and souvenir exporting business in Cebu City. Her extradition to the United States was requested. When agents looked at the record, they found Leventis and Flores had conducted the business for six years, back to 1991. The Philippine government had banned coral exports in 1977.

DEMAND PULL ECONOMICS

Virtually all of the trade in CITES species is created by commercial requests to meet consumer demand. The import of tons of caviar or thousands of birds is beyond the scope of individual gourmands or pet collectors. The trade is made possible by its middlemen, the specialists who run seashell shops, supermarkets and pet stores.

Some bird fanciers claim they are helping "save the species." This assertion is discredited by their suppliers who steal eggs from nests in Australia and buy parrots fresh from forbidden jungles. Add the fact that these birds will never be able to return to the wild and the impact of the theft is clear: species annihilation. The list of traded endangered species is longer than this book.

While some smugglers may claim "Robin Hood status" by supplying folks what they want, the contraband they peddle is sustainable—cigars, marijuana, cocaine, arms and money. Wildlife is not. From the fins of sharks to the hands of gorillas to the horns of rhinoceros, animals around the globe are being slaughtered for their parts to tickle the fancies of the wealthy.

If animals and their parts were not considered valuable, the trade would cease immediately. Economic demand lies at the heart of smuggling and the category of plant and animal products is no different.

THE POT HAULERS

Marijuana's lethargic effects were known long before the Spanish came to Florida. The famous Native American "peace pipe" was probably stuffed with dried cannabis leaves. Queen Victoria of Britain used it to ease her menstrual cramps; jazz trumpeter Louis Armstrong was a lifelong marijuana fan, as was astronomer Carl Sagan. Marijuana was once legal in the United States; grocers sold it in bulk and newsstands sold it in small bags with cigarette papers attached.

The Federal Marijuana Tax Act of 1937 put an end to legal cannabis. Four years after the alcohol Prohibition ended, the Marijuana Prohibition began. Sale and consumption went underground and use of the drug rose sharply in the 1960s, as younger Americans in the counterculture experimented with it and enjoyed its effects. Confiscations of contraband rose.

In hindsight, the quantity of seizures in the late 1960s seems puny. In fiscal year 1965–66, 10,000 pounds of marijuana were seized by customs and drug agents in the United States. In 1966–67, the amount grew to 26,000 pounds and in 1967–68 seizures reached 70,000 pounds. With its vast coastline, Florida was perfectly poised to supply the growing demand for marijuana in the 1970s. While no coastal area was exempt, the best-documented cases occurred along the sugar-sand and mangrove choked western shores.

Commercial fishermen had fallen on hard times and found they could earn more in a day offloading a mother ship full of pot than they could in a year of backbreaking honest labor. In the beginning, it was a family-and-friends affair. Word would be spread that "a load" was coming and fishermen would quietly slip into their small boats for a midnight rendezvous. The scene could be comical, as Totch Brown describes in his autobiography, *My Life in the Everglades*: "Most every crewman was new at pot-hauling, like myself, and the boats we used were too small and were overloaded. Several sank; others were leaky and the pot got wet. Above all, bad weather brought in the tidewater higher than normal and soaked some of what we'd stashed away."

This represented a huge marijuana bust in 1963, with newspaper mentions across the country. A decade later, it's doubtful this size of seizure would rate any mention at all. Consumption and demand soared in the 1960s and 1970s. Eventually hundreds of tons of marijuana were confiscated and millions more tons were smuggled successfully. *Courtesy Library of Congress.*

The story of Florida's homegrown pot smugglers first emerged publicly when a shrimp boat ran aground near Steinhatchee in the Big Bend area in 1973. John Rothchild returned to the area a decade later to write about what happened next (from the January 1983 edition of *Harper's Monthly*):

The first time any of the local fishermen saw a bale, or even a stalk, was after one of Floyd Bubba Capo's boats ran aground on a shoal in nearby Rocky Creek in 1973. J. Bryant Lytle saw the bales from his own boat. 'I didn't know what the shit it was,' he said. 'I thought it was some kind of bayonet trees from over on Pepperfish Island.' (Lytle himself went to jail for the Watermelon Truck Stop deal). Another fisherman took a sample from one of the bales over to the sheriff's department, where then deputy Glen Dyals, now the head sheriff and under considerable suspicion himself, suggested that he thought it was marijuana and his department could take some credit for the nine-ton bust, the biggest in U.S. history up to then. The case was taken over by the Florida Department of Law Enforcement and prosecuted out

When Florida's pot haulers talk about a shrimp boat, this is the craft to which they refer. Economical to operate and cheap to buy with substantial cargo capacity and good sea keeping qualities—they were perfect for Florida's west coast pot haulers. They are still common along the Gulf Coast. *Courtesy National Oceanic and Atmospheric Administration.*

of the area for reasons that will soon be apparent. Those arrested in the bust were called the Steinhatchee Seven, a prophetic misnomer. Six of them were middle-class kids from St. Petersburg, and the seventh was [Floyd Bubba] Capo, who lived down at Horseshoe Beach, 15 miles away. In 1973, most of the regular Steinhatchee fishermen bristled at the headlines that connected them with drug smugglers, just because a boat happened to end up in one of their creeks. By 1976, Capo was the fisherman everybody wanted to emulate. As his business flourished, he donated money for crippled children, needy families and civic organizations, and he even built his wife a church near Horseshoe Beach.

For a hand-to-mouth fisherman, the proceeds were astounding. One night's work offloading bales and bringing them ashore netted $10,000. The largesse, according to court records, didn't stop at the fishermen. A county deputy sheriff could receive $20,000 for simply staying away. And for the mastermind executive who put the deal together, one load was worth $500,000 profit.

Floyd Bubba Capo was not a Steinhatchee native. He hailed from the fishing village of Cortez, Florida. That tightly knit community too was involved in the trade of pot hauling. Ben Green's exploration of Cortezian

history (*Finest Kind: A Celebration of a Florida Fishing Village*) devotes an entire chapter to pot smuggling, with a focus on one man—Raymond Luther Guthrie Jr., better known as "Junior."

> *Junior Guthrie was described by the* Sarasota Herald-Tribune *as "a fearless, powerfully built man and Robin Hood-style character in many smuggling legends of Southwest Florida." The only legends Junior is associated with in Cortez have to do with how many grades he flunked in school and the stupid dares that he was always willing to take as a kid. If you wanted to challenge somebody to dive headfirst off the roof of the dock at low tide, Junior was your boy. The only thing that Junior was ever good at, and he was very good at that, was catching fish. And as the testimony unfolded about his smuggling career—bungled attempts, shortchanged payments, mechanical failures—one could argue that fishing was still the only thing he did well.*

At the age of thirty-four, Junior was charged with importing 246,000 pounds of marijuana, valued at $23 million. His trial opened in Tallahassee Federal Court on August 22, 1983. Big drug trials were commonplace in Florida at the time. Excluding the lawyers, bailiffs, clerks, judge and defendants, only four people were present: Junior's mother and father and two reporters for Junior's hometown papers, the *Bradenton Herald* and the *Sarasota Herald-Tribune*.

The majority of Cortezians were not smugglers. But they knew what was happening. "The smuggling was a silent backdrop to their lives," wrote Green. "They heard the boats coming in at odd hours, saw the new vans and Lincoln continentals parked in front of Junior's house, and gazed suspiciously at the burned-out derelicts who descended on Cortez like locusts, hoping to get a job on a fishing boat and get in on a few runs."

The new wealth could not be concealed. Old fishermen's shacks along the west coast sported new porches and new vans were parked in new garages. New boats, new motors, new clothes, gold jewelry, all on a $10,000 fisherman's income. But because many of these men and women lived in small fishing villages like Cortez, Steinhatchee and Everglades City, the sudden wealth was mostly invisible. To the fishing families, it seemed a long-overdue bonanza, a payoff for decades of hard and dangerous toil on the water.

But as the circle of wealth began to spread, so did the circle of corruption. John Rothchild at this time lived in Everglades City and described a pretrial gathering in his book, *Up For Grabs*.

> *The night before he went to trial,* [Richard] *Wolferts gave a huge party, attended by more than half the town, including all the local deputies and a majority of the local smugglers. He dressed up in a black-and-white convict suit and seemed to be in a great humor, on the wall near the serving line for the barbecued wild hog he put up a wooden plaque, the kind used in mounting stuffed fish, but his prized catch was a burlap bale. Deputies and smugglers danced and reveled for hours in suspicious togetherness.*

The mechanics of the trade were simple. An organizer ("the key man") would travel to Colombia and arrange for the supply of marijuana. A trusted local contact would remain to ensure the burlap-covered bales actually contained cannabis and not banana leaves or other trash.

Then the organizer would arrange for a commercial shrimp boat or small freighter to arrive at a small port in northern Colombia, load the bales and steam north to Florida. There, small boats would come out from the coast, load up and return to put the pot in hideouts. Later trucks would come to pick up the load. Sometimes the load would be sold in bulk and sometimes it would be parceled out.

Totch Brown admits to participating in eight smuggling events, starting as a simple pot hauler with a small boat and ending as a major organizer. Here he describes his seventh operation.

> *Nine days later, right on schedule, she made her rendezvous off the Florida coast. This business hardly ever turns out like it's planned, and this being my first shot at buying and selling, it turned out bad. First off, those crooks only gave my crew about half a load, and like most always, at least have [sic] of that was junk. I do believe they packed in everything from dried banana leaves to seaweed with that marijuana. The first buyer I tried turned it down flat. The second buyer stole what he got—and never paid me a dime. The next truckload never even made it to the buyer; the boys in the warehouse ripped me off. Finally, though, before losing it all, I made a cash sale big enough to put me back on my feet and give me time to look around a little.*

Totch, like so many of his pot-hauling colleagues, eventually was arrested. In his case, it was for income tax evasion. Rothchild wrote, "Totch, who lived in a small cottage on Chokoloskee Island, eventually showed up in federal court in Miami to answer an IRS complaint about having falsified his taxable income, and with his gnarled hands, the

[*Miami*] *Herald* reported, he produced a cashier's check for more than $1 million, and offered up a similar amount in property in the hope it would settle his little debt to the government."

Junior too got a call from the tax man. "When the Internal Revenue Service filed suit against him in March 1982 for $483,220 in back taxes on unreported income, it looked as though Junior might fall victim to the same fate as Al Capone," Green wrote. "When Junior paid them the money, thinking that would shut them up, the IRS immediately wanted to know how he got the money to pay it. Discretion in spending money was never one of Junior's strong suits." The *Sarasota Herald-Tribune* reported on August 31, 1983, that Junior's net worth in 1980 was $1.7 million, up from $47,392 in 1976. As Green might say, "That's a lot of fish."

Eventually it all fell apart. Totch, Bubba and Junior all ended up in the slammer, along with a lot of other, seemingly more respectable folks. "Smuggling in Manatee County had become so rampant by 1980 that a state grand jury was convened in Bradenton in July of that year. It began investigating politicians, law enforcement officers and financiers with possible smuggling connections," Green wrote. "Several prominent figures were eventually indicted, including Jerome Pratt, an attorney and former state legislator, and Afton Pyles, a former Palmetto police lieutenant."

Before Brown was sentenced, the *Miami Herald* ran an editorial in his defense, saying: "How do you sentence a man like Totch Brown? A veteran of the Battle of the Bulge, a Bronze Star winner, with nearly fifty years of close family ties, who handed out thousands of dollars to his neighbors in need and never in serious trouble before."

Totch spent fifteen months in federal prison. It was time well served because it was the genesis of his marvelous autobiography of growing up and living in the Ten Thousand Islands. He was a living link among the plume hunters, rumrunners, gator skinners and pot haulers who form one leg of the maritime history of Florida.

Once again, some of the proceeds from the smuggling trade ended up in real estate, as Totch's settlement offer indicates. The 1970s was the beginning of the condominium era for the Florida west coast. When you look at the beachfront skyline today, you realize the proceeds from pot hauling laid many of their foundations.

"Marijuana and commercial fishing were the only two local businesses not controlled by outside corporate forces," wrote Rothchild in *Harper's*. "Both were father-and-son efforts, both required similar skills and even similar hours; but with marijuana you could work once a year. There was

friendliness and neighborliness on the job. In fact, the small-town ethic still defined the smuggling." But not for long.

In the late 1970s, the American farmer out of desperation rediscovered marijuana; by the mid-1980s, domestic cannabis production began to undercut the Colombian product in price and quality. In some areas of the United States, the Department of Agriculture indicated pot was the top cash crop. The profitability of smuggling it from Colombia declined, just as the risks of getting caught began to escalate. Marijuana smuggling required too many large assets: boats, trucks, offloading crews, warehouses and all those bales.

As the 1970s came to a close, a new breed of smuggler began to emerge. The Totch Browns, Junior Guthries, Bubba Capos and their fishermen friends were pushed aside by a tougher crowd. The illegal drug of choice was changing and the smuggling market adapted swiftly.

Marijuana hasn't gone away. In 2003, more than 2.5 million tons of marijuana was seized in the southwestern United States. It is no longer a mom and pop business and the days of misadventure have given way to corporate-like efficiency. Florida as a port of entry for pot is enjoying a resurgence. The National Drug Threat Assessment 2005 says:

> *The South Florida area remains a primary entry point for foreign-produced marijuana smuggled through the Caribbean and is emerging as a regional source of supply for domestic marijuana. Law enforcement reporting and seizure data indicate that Florida, particularly the southern portion of the state, continues to be a focal point for maritime smuggling of marijuana from source areas such as Colombia and Jamaica. But in the past few years, as seizures specifically at the port of Miami have declined, reporting indicates that shipments are entering Florida at various points along the state's Atlantic Coast, particularly from Miami to Port St. Lucie, and at the southern tip.*

In the early 1980s, a vastly overweight man named Ed Chance was elected to the Manatee County Commission. His primary trade was barbering. He sang country and western songs on the weekends. One day I spied a guitar in the corner of his office. "Do you play?" I asked naïvely.

"Well, sure," said Chance. He picked up that guitar and sang "The Ballad of Junior Guthrie." Then he told me the time somebody put a brown grocery bag full of high-denomination bills on the front steps of the Manatee County Sheriff's Office. "A donation from the Manatee County smugglers," the note said.

Marijuana never disappeared from the smuggling scene, although the trade shifted dramatically to the southwestern border in the late 1990s. But Florida continued to haul its share. Here two "coasties" from the cutter *Monhegan* stack "square grouper" on the dock at Key West in 2001. *Courtesy U.S. Coast Guard.*

On Florida's west coast, from Everglades City to Steinhatchee, the pot haulers remained part of their communities. They built churches, donated money quietly, didn't hurt anybody and—for the most part—faded into the general population when the game was over. A few were busted, but many more emerged unscathed to invest their profits wisely and well.

EIGHT

FROM HANDSHAKES TO HANDGUNS

In the 1970s the illegal drug of choice was changing and the smuggling market adapted swiftly. Fortunately for the smugglers, interest was growing in another illicit drug that beat marijuana on every point—higher profits, lower bulk and fewer people. It was cocaine. *Miami Herald* reporters Guy Gugliotta and Jeff Leen in their book *Kings of Cocaine* described the transition: "The country's tastes were changing from marijuana to cocaine, and surging demand sent the price sky high: a kilogram (2.2 pounds) of cocaine, the standard unit of measure in the trade, sold for $51,000 in Miami, up from $34,000 just a year earlier. And there were more kilos coming in than ever before. South Florida was a smuggler's paradise. Miami was closer to Barranquilla, Colombia, than to Chicago and Florida had 8,246 miles of shoreline to patrol."

The drug in its natural state was used for centuries by Native Americans in the Andes. They obtained its effects by chewing the leaves of the coca plant. It wasn't until 1855 that European chemists were able to isolate the active ingredient and create a formula for its production. The chemists called it cocaine, and it became quite popular. Users included President Ulysses S. Grant, Popes Leo XIII and Saint Pius X and Queen Victoria of England (who, as mentioned in chapter seven, was also a fan of marijuana).

Sigmund Freud wrote in *Über Coca* (1884) that cocaine produces "exhilaration and lasting euphoria, which in no way differs from the normal euphoria of the healthy person...You perceive an increase of self-control and possess more vitality and capacity for work...In other words, you are simply normal, and it is soon hard to believe you are under the influence of any drug...Long intensive physical work is performed without any fatigue...This result is enjoyed without any of the unpleasant after-effects that follow exhilaration brought about by alcohol...Absolutely no craving for the further use of cocaine appears after the first, or even after repeated taking of the drug."

Despite Dr. Freud's conclusion, cocaine is seriously addictive. It was outlawed in 1922, only two years after Prohibition went into effect. The impact of the cocaine ban was immediate. "Federal narcotics agents based in Tampa added to the alarm," wrote Michael Mundt in the November 1996 *Journal of the Tampa Historical Society*. "In 1923, they revealed to the press that drug prices were falling as Tampa's dealers waged a 'dope war,' flooding the city's streets with greater amounts of narcotics to maintain profits. These agents observed that Tampa was rapidly becoming a 'notorious' drug selling and smuggling center, drawing addicts from across the south."

Four times, Tampa's "federal narcotics agents" showed up in the Tampa press during the year following cocaine's ban. In retrospect, considering the times, it seems like scaremongering by a new bureaucracy to get more money. As we'll see, this tactic works as well now as it did then.

Some rumrunners emerged from Prohibition to create large organized crime industries embracing a number of vices. But cocaine smuggling remained an oddity until the late 1970s, when it emerged in a hail of gunfire and headlines. Then it was a real scare. Gugliotta and Leen covered it for the *Miami Herald* as on-the-scene reporters and then wrote in their book:

> *Metropolitan Dade County would become for a time the murder capital of the nation, and south Florida would see an unprecedented federal police effort against drug smuggling. Yet the cocaine trade would grow phenomenally, a deluge beyond prediction. In fiscal 1977, U.S. law enforcement seized 952 pounds of cocaine in the entire country, and estimated the total amount of imported cocaine at 19,000 pounds. Four years later, a single Miami drug importer working for the Colombians would bring in 38,000 pounds in seven months without suffering a single seizure. In 1986 federal law enforcement agents in the south Florida region alone would seize more than 50,000 pounds of cocaine. By the end of the decade any cocaine seizure under a ton barely rated a mention in* The Miami Herald's *local news pages.*

While Florida's pot hauls were family-and-neighbor affairs, the cocaine smugglers were a more ruthless group. A saying began to circulate in the early 1980s: a pot deal is done with a handshake; a coke deal is done with a gun. In Miami, there was a lot of gunfire. Again, Gugliotta and Leen:

> The Miami Herald *detailed a series of drug executions the likes of which the locals had never seen. Colombians were dying in all sorts of interesting ways: stuffed in a cardboard box and dumped in the*

Everglades; delivered DOA to an emergency room in a white Cadillac; wrapped in plastic and dumped in a canal in Coral Gables; machine-gunned to death while sitting in noon-time traffic. 'It's Dodge City all over again,' said a federal prosecutor. 'A replay of Chicago in the 1920s,' a county coroner called it. Colombians crowded the Dade County morgue—Dead County, the Colombians called it.

As the nation recoiled in horror, the president decided to send help. On January 28, 1982, President Ronald Reagan formed the South Florida Drug Task Force. More than two thousand agents of the FBI, the Drug Enforcement Administration (DEA), Alcohol Tobacco and Firearms and Customs deployed to Miami to fight the cocaine smugglers. And in a repeat of Colonel Nutt's efforts sixty years earlier, navy ships and aircraft were assigned interception duty.

Heading up the task force was Vice President George H.W. Bush, who told the National Press Club on June 17, 1983: "In a very brief period of time we sent to South Florida additional federal judges, more prosecuting attorneys and hundreds of additional law enforcement personnel. We beefed up the Coast Guard, solicited and received help from the Defense Department including the Navy, the Army, the Air Force and the Marines. We intensified our diplomatic initiatives, which resulted in improved co-operation with the Bahamian Government and some of our Latin American friends. The results have been gratifying."

Not everybody thought the effort was a success. "A year after the task force arrived, the price of a kilo of cocaine dropped from $55,000 to $13,000, a record low and [an] indication of a massive glut at the wholesale level," Gugliotta and Lean wrote.

NEW TOYS, OLD TACTICS

In the beginning, cocaine smugglers used aircraft to ferry their cargo from Colombia to south Florida. They often landed at undeveloped subdivisions, which had paved streets but no residents. Proto-cities like North Port contained hundreds of miles of empty streets, paved by developers but lined with unsold lots. One Sarasota County sheriff's deputy called the area "North Port International." Other proto-cities like Cape Coral became clandestine airports as well. Police would often find abandoned aircraft parked in North Port, retired after one flight. The distinctive roar of low-flying DC-3s became a familiar nighttime sound in the Everglades and Ten Thousand Islands. For the pilots, the payoff was immense: $3,500 per kilo.

But with increased radar and aerial surveillance, the smugglers returned to the age-old, tried-and-true route—the sea. Again they used the mother ship for bulk and a go-fast speedboat for infiltration to shore. Often the mother ship would anchor in Bahamian waters for the rendezvous. Authorities moved to thwart the smugglers with intensified maritime patrols. And smugglers changed procedures to thwart the authorities.

As the surveillance intensified, the mother-ship system was abandoned, and a brand new technique was pioneered. Gugliotta and Leen used the testimony of a man who later came into the Federal Witness Protection Program to describe it.

> *Max* [Mermelstein] *had subcontracted with a group of American pilots and powerboaters to bring in tons of cocaine for the cartel. Beginning in September 1982, the smuggling group's aircraft, a Piper Navajo, flew from Colombia and air-dropped cocaine into the waters off Long Cay in the Bahamas. The plane then continued on to Nassau, where it picked up 'cover girls,' women paid $2,000 to pose as tourists for the flight in south Florida. Meanwhile, the floating cocaine was retrieved by crews in speedboats who made the seventy-five mile run into Miami at speeds of up to 90 miles per hour—each run required a new $100,000 engine. A 'spotter plane' circled the drop site looking out for Customs planes. Under cover of darkness, the boats slipped into Biscayne Bay while a lookout with binoculars scanned the water from the eleventh floor of a nearby condominium. A communications center in Miami monitored law enforcement frequencies and provided the radio linkup for the planes and boats. Except for the cocaine getting wet, the system was foolproof. Load after load got through undetected.*

Authorities had no idea how much cocaine was coming into the country. One indicator—the total annual seizures—showed the trade had swelled forty-fold. In 1981 a total of 4,000 pounds of cocaine was seized; in 1988, it was 150,000 pounds.

Commercial traffic was used to camouflage loads too. A cargo of streetlights was brought in from Colombia by freighter; cocaine was found inside the poles. Virtually every legitimate exportable commodity from Colombia—even flowers—was used to disguise the real cargo of cocaine.

As the business soared, the cocaine economy became vertically integrated, and cartels were created to manage the multibillion-dollar industry. The money came back to Colombia, either through money-laundering schemes or pure smuggling of bundles of cash. The cartels used the cash not only

Halting cocaine smuggling at sea is now a cross-discipline, multinational effort. These bales of cocaine on the dock at Tampa were seized by a "tactical law enforcement team" working with a Dutch warship in the Antilles. More than a ton of cocaine was aboard the ship in the background. *Courtesy U.S. Coast Guard.*

for their personal opulence, but also to build schools, athletic stadiums and other civic buildings in Colombia. Some of the profits were used to start legitimate businesses, which could be used to smuggle more cocaine or to accept laundered monies in return.

For "muscle," the cartels made alliances with Colombian revolutionaries to provide security for coca growers and jungle laboratories. The term "narco-terrorist" was born from this unholy alliance. The money distributed to both right- and left-wing insurgents was used to fund revolutionary cadres, purchase arms and hire mercenaries for training.

The Colombian partnership between the cartels and the rebels formed a model for other smugglers and insurgents across the globe. Heroin production and export, for example, funded the Taliban government of Afghanistan. After a short interlude following the Taliban's expulsion by U.S.-led forces, heroin production now exceeds the pre-invasion levels. The cartels in Colombia proved that it may be cheaper for drug organizations to "outsource" their security requirements (either with suborned government forces or rebels) than to provide it internally.

Money was put into Colombia's political and judicial systems. Cartel candidates openly ran for local, regional and national office. Law enforcement and military officials received largesse from the cartels. Colombian politicians who resisted the inducements faced intimidation and assassination. The objective of the cartel's campaign was to block extradition of cartel leaders to the United States, and it worked. For years, cartel figures were either free or spent time in comfortable Colombian jail cells. Meanwhile the cocaine continued to flow into Florida.

In addition to fighting extradition, hiring rebels for protection and suborning Colombian officials, the cartels also tried to do what Al Capone did for the Chicago booze trade—intimidate or exterminate the opposition. By the late 1980s, it boiled down to the final two surviving competitors, named after their respective headquarters: the Cali Cartel and the Medellín Cartel. Although it took almost twenty years, when the smoke cleared both cartels lay in ruins.

The organizations had extensive connections in Florida, both as the destination of their illicit cargoes and the beneficiary of their investments. The end began in 1988 with the sentencing of Carlos Lehder—a flamboyant Medellín cocaine entrepreneur and prime target of U.S. drug agents—in federal court. U.S. District Judge Howell Melton gave Lehder 135 years in prison with no possibility of parole.

With Lehder out of circulation during his trial, the Cali Cartel was free to build up its importation and distribution business. But it had to muscle past the Medellín organization. The wake-up call came in January when a car

bomb exploded in Medellín, outside the apartment building where cartel chief Pablo Escobar's wife and son were living.

Murder rates in both cities escalated to all-time highs. "Homicide rates in the city of Cali, Colombia (1994 population: 1,776,436), increased fivefold from 1985 through 1992, reaching levels of 100 per 100,000 persons," a government report stated. In other words, there was one chance in a thousand of being murdered in Cali in 1992. That's more than five murders per day.

THE CUBAN CONNECTION AGAIN

The combination of drugs and politics reached from Colombia to Cuba in 1989, when four military officers were tried, convicted and executed for drug crimes by the Castro government. Among those found guilty was Major General Arnoldo Ochoa, a highly decorated military hero.

Speculation continues that Cuban President Fidel Castro used the drug charges to purge Ochoa, who had become critical of the communist government. Other speculation says Ochoa was sacrificed to protect the

Aircraft are used to interdict smugglers too. Although a "shoot down" rule was never approved, the "shot across the bow" has been part of maritime law for centuries. Here a coast guard MH-90 lays a machine-gun burst in front of a smuggler's "go fast." The MH-90 has no tail rotor and is much quieter than a conventional helicopter. In addition to the machine gun, it also carries a .50-caliber sniper rifle to disable engines. *Courtesy U.S. Coast Guard.*

core of a secret: Cuba was involved deeply with the drug trade and had been for at least a decade.

On February 5, 1991, the PBS documentary *Frontline* aired "Cuba and Cocaine." Four years before the trial of Ochoa, senior Cuban officials approved the use of Cuban waters and airspace by cocaine smugglers, *Frontline* reported. "In the western part of Cuba, we have 19 SAM missile sites and we have hundreds of radars and we have a regiment of MiG-23 interceptors. And it is completely impossible that a small airplane fly from Colombia to the United States without the knowledge and the permission of the Cuban authority," said Cuban Air Force General Rafael del Pino, the highest ranking military officer to defect from Castro's Cuba.

Aircraft would fly from Colombia with cargoes of cocaine, airdrop them to waiting high-speed powerboats and then return to Cuban airfields to refuel. U.S. Coast Guard boats, watching from outside the twelve-mile limit, saw it happen sixty-four times in a twelve-month period.

The "key man" was Reinaldo Ruiz. He was a cocaine smuggler with family connections inside Fidel Castro's inner circle. He eventually was caught, convicted and began to talk of his Cuban connection. "Every time that I went over there, I was completely sure that I had a 100 percent backing, all the way to the top, otherwise I never, ever touch a thing out there," he told *Frontline*. "When you go to a place, an office, and everything is resolved, everything is taken care and people play with cocaine like it was mangoes and oranges or whatever, you know—I mean, you know that everything is controlled."

Cuba was taking a commission on every kilo passing above or around the island. It was providing escorts for drug-laden freighters, fuel for smugglers' aircraft and even top-drawer rest and relaxation facilities for the smugglers themselves.

On July 26, 1989, Ambassador Melvin Levitsky, assistant secretary of state for international narcotics matters, testified to Congress: "There is no doubt that Cuba is a transit point in the illegal drug flow…We have made a major commitment to interdicting this traffic…Although it is difficult to gauge the amount of trafficking that takes place in Cuba, we note a marked increase in reported drug trafficking incidents in Cuban territory during the first half of 1989."

With Ruiz talking to U.S. prosecutors about his Cuban connections, the Cuban government reacted quickly. The four military officers were arrested, led through a show trial and executed. Any link between Castro and cocaine was severed.

The arrest, trial, conviction and execution were widely covered in the Cuban press. It included a very rare televised speech by Raul Castro, Fidel's brother, Cuban minister of defense and heir apparent. It was unusual

because Raul Castro rarely spoke in public. His two-hour speech is still studied by "Cuba watchers." In announcing the capture of the ringleaders, Fidel Castro mentioned Pablo Escobar several times in his speech.

Escobar started life as a small-time car thief and became one of the richest men in the world. His strategy was simple: "plata o plomo," Spanish for "gold or lead," take the bribe or the bullet. At its zenith, his Medellín Cartel was taking in $25 billion annually. *Forbes* magazine rated him the seventh-richest private individual on the planet in 1989.

CARTEL IMMOLATION

As the cartel wars escalated, Escobar developed a unique survival strategy. He built a luxurious wing on a prison in 1991, and then surrendered to Colombian authorities on the condition he stay in his home-built jail and not be extradited to the United States. Escobar remained in his prison-cum-fortress about one year and then "escaped" when authorities wanted to relocate him.

Escobar went into hiding with thousands of people on his trail. U.S. Navy SEALs and Delta Force operatives joined the hunt and trained a special Colombian law enforcement team call the Search Bloc. In addition, a paramilitary group called the PPES (People Persecuted by Escobar) launched an all-out vigilante war on the Medellín Cartel. It destroyed cartel properties and assassinated more than three hundred Escobar associates.

The relationship between the U.S. government, the Search Bloc and the PPES death squads remains elusive. Without question there was widespread sharing of intelligence, and there is some evidence Search Bloc members were associated with PPES activities.

It came to an end on December 2, 1993. Escobar was isolated in an apartment building in a middle-class neighborhood of Medellín, surrounded by the Search Bloc and killed by a bullet behind his ear. The Medellín Cartel and its leader were no more. While the Colombian government was one beneficiary of the shootout, the big winner was Escobar's competition—the Cali Cartel.

The group in Cali operated with less flamboyance than Escobar's Medellín crowd, preferring the bribe to the bullet. Once it became the dominant player, it was able to work in cooperation with smaller organizations to avoid open warfare. They were able, as Al Capone did decades before, to co-opt and integrate competitors into one large, smoothly operating smuggling machine.

By the mid-1990s, cocaine smuggling moved off the front pages and returned to being a covert trade. As the gunfire receded, control centralized and the trade increased. In 1999, for example, fifty-eight

baggage handlers and food-service workers at Miami International Airport were arrested for using commercial airliners to smuggle cocaine. It was the power of "la plata."

Like many continuing criminal enterprises, the Cali Cartel was a family affair with the Rodriguez-Orejuela clan. For nearly thirty years, the leader, Gilberto Rodriguez-Orejuela—nicknamed "the chess player"—was a pioneer in the drug trade. His brother Miguel ran the day-to-day operations.

Gilberto first came to the attention of serious law enforcement in 1978, when warrants for his arrest on drug trafficking charges were issued by authorities in New York and Los Angeles. He showed up again in 1984, when he was arrested in Spain at the height of the cartel quarrel. In his hotel room was a ledger detailing shipment of four metric tons of cocaine.

By February 1985, Gilberto was featured in *Newsweek* as one of the "Kings of Coke." It took almost two years for the Colombian government to successfully extradite Gilberto from Spain for trial on drug trafficking charges. After a five-month trial in Cali, Gilberto was found not guilty.

Gilberto was rearrested almost a decade later in 1995 in a house surrounded by three thousand Colombian police and drug agents. They almost missed him, as he hid in a crawl space behind a moveable bookcase. His brother was captured the following year. Both were tried, found guilty and sentenced to Colombia's La Picota prison. At that time, the DEA estimated annual profits for the Cali Cartel exceeded $8 billion, and the organization controlled 80 percent of the global cocaine market. Gilberto was released in 2002 for "good behavior," but public outrage in Colombia led to his rearrest four months later.

The brothers were also indicted in the United States in 1995, along with fifty-four other people. Among them was a senior U.S. Department of Justice lawyer, who left the department in 1984 and took up Gilberto and Miguel as clients. American efforts to extradite the brothers succeeded in 2004, when Colombia agreed to extradite them to stand trial in the United States on drug trafficking charges. They appeared in Miami Federal Court on December 6, 2004. The indictment sought a forfeiture of more than $2 billion. The Associated Press reported at the time:

> *The cartel became renowned for its ingenious methods of hiding tons of cocaine in everything from hollow lumber and concrete fence posts to chlorine cylinders, frozen broccoli and okra. Investigators believe a 15-ton seizure of cocaine-stuffed fence posts in Miami in 1991 followed more than 20 similar shipments that passed through undetected. "The way the cocaine is concealed, it's brilliant," said Tom Cash, head of the Drug Enforcement Administration in*

Miami during the cartel's heyday in the 1990s. "If you go back and think of all the major traffickers from certainly the '90s and even into the 2000s, there's nobody in their class. They're in a class by themselves," Cash said. "By magnitude, by money, by class of corruption."

When Gilberto and Miguel went to prison in Colombia (and were subsequently extradited to the United States), the operation of the cartel fell to Miguel's son, William Rodriguez-Abadia. In early 2006, William pled guilty to drug trafficking charges and agreed to cooperate with U.S. authorities by testifying against his father and uncle. A DEA press release on the guilty plea of William Rodriguez-Abadia on March 9, 2006 says:

According to the factual proffer read by an Assistant United States Attorney at the plea hearing, Rodriguez-Abadia—beginning in 1995, coinciding with the arrest of his father, Miguel Rodriguez-Orejuela, and at his father's request—began to run various aspects of the Cali cartel, an international drug syndicate directed for many years by his father and his uncle, Gilberto Rodriguez-Orejuela. In particular, Rodriguez-Abadia was placed in charge of administering his father's portion of the Rodriguez-Orejuela family business enterprises, including Drogas La Rebaja, S.A., a pharmacy chain of approximately 350 pharmacies in Colombia; Laboratorios Kressfor de Colombia, S.A., a pharmaceutical manufacturing company in Colombia; and various other entities in Colombia. Rodriguez-Abadia helped initiate, develop, implement and otherwise manage plans to launder and further conceal the Rodriguez-Orejuelas' drug profits through a variety of schemes involving these business entities. In addition, according to the proffer, Rodriguez-Abadia was responsible for arranging and ensuring the payment of bribe monies and payoffs to incarcerated cartel employees and their families. These bribes and payoffs were made in an effort to prevent such cartel employees from becoming witnesses against Miguel Rodriguez-Orejuela and Gilberto Rodriguez-Orejuela.

William was for a decade the "political department" of the Cali Cartel, responsible for bribes, payoffs and money laundering. His plea and cooperation effectively will destroy the Cali organization. He received a twenty-two-year sentence, if he continues to cooperate with the authorities. One week before William's 2006 deal with prosecutors was announced,

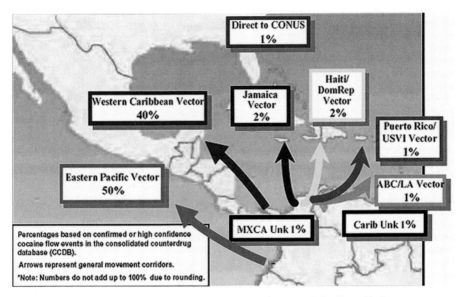

This map is from the 2006 Drug Threat Assessment Report of the Drug Enforcement Administration, based on 2004 data. It reflects the dramatic diversion of the Colombian cocaine trade from Florida to the southwestern United States, where today 90 percent of the country's cocaine is smuggled through the border. Twenty years earlier, before the self-destruction of the Colombian cocaine cartels, 90 percent came through Florida. *Courtesy Drug Enforcement Administration.*

the U.S. Attorney's office in New York unveiled indictments against fifty members of the Revolutionary Armed Forces of Colombia (FARC), a terrorist organization known to have worked with the cartel. The website *moneylaundering.com* reported:

> *Although the FARC initially confined its role to taxing narcotics manufacturers, distributors and traffickers in the Colombian territories it controls, the group eventually became directly involved in the cocaine production to cash in on increasing profits, according to the indictment. Among other things, it set the prices paid to Colombian farmers for cocaine paste, the raw material used to produce cocaine, and for transporting it to jungle laboratories under FARC control, where it was converted into tons of the narcotic and shipped to the United States and elsewhere. As a result, FARC supplies more than 50 percent of the world's cocaine and more than 60 percent of the cocaine that enters the United States, the indictment states, and spent millions of dollars of its illicit proceeds to purchase weapons for terrorist activities against Colombia, according to the U.S. Attorney's Office in Manhattan.*

"From their jungle hideaway, the FARC uses the drug trade to bankroll terrorism in Colombia, finance attacks on innocent citizens, and poison Americans," DEA Administrator Karen P. Tandy said.

The torch has passed. Leaders of the sole surviving Colombian cocaine cartel of the late twentieth century are now old men in federal custody or younger men helping authorities dismantle the organization. The bodies of others litter the historical landscape. But still the drugs flow. In fiscal year 2004, federal agents seized 242,000 pounds of cocaine at sea—an all-time high. More than 100 tons seized at sea and still the price didn't go down.

The bulk of these seizures, however, did not come in the Gulf of Mexico. Florida was not their destination. A new cocaine smuggling organization supplanted the Colombian cartels and Florida is now a minor port of entry. The trade moved to Mexico.

The Drug Enforcement Agency's "National Drug Threat Assessment 2006" states: "Cocaine transportation data indicate that most cocaine available in U.S. drug markets is smuggled into the country via the U.S.–Mexico border. As Mexican DTOs [Drug Trafficking Organizations] and criminal groups control an increasing percentage of the cocaine smuggled into the country, their influence over wholesale distribution will rise even in areas previously controlled by other groups, including areas of the Northeast and Florida/Caribbean Regions."

The DEA estimates wholesale-level drug distribution in the United States generates between $13.6 billion and $48.4 billion annually. After performing a leading role in the cocaine drama for a quarter century, Florida is now a bit player, but the show goes on.

NINE

MONEY MATTERS

Every smuggling racket is a cash business. It may not pay taxes or provide health care, but it still has bills to pay and payrolls to meet. As the racket grows and flourishes, the amount of cash starts to pile up. One pound of cocaine is worth six pounds of $20 bills. Prior to the 1970s, this wasn't a problem. Anyone could walk into a bank with a trunk full of $100 bills, make a deposit and walk away with a receipt.

As Al Capone discovered, unreported income can create problems with the Internal Revenue Service. So smart smugglers began to keep a substantial fraction of their assets in foreign banks. A variety of nations set up bank secrecy laws (Isle of Man, Cayman Islands, Liechtenstein) to encourage anonymous currency to find a permanent home. But you had to get it there.

In the mid-1970s, a new term entered the language: money laundering. The phrase came from the world of politics, where sources of campaign funding were disguised to conceal the identity of the real contributor. The Watergate scandal popularized the term worldwide.

As the drug industry ramped up in Florida, shopping bags full of cash were spotted more frequently by bank tellers. Mike McDonald of the IRS noted: "We had people walking in with rope-handled shopping bags and deposit slips going into banks. We had 12 individuals in Miami who were depositing $250 million or more annually into non-interest-bearing checking accounts."

In 1980 McDonald was about to launch an attack on money laundering in Miami called Operation Greenback. The first raid had an unexpectedly fatal consequence, he explained to an interviewer for PBS's *Frontline*: "We did our first seizure, which was an airplane that was taking $1.2 million down to Colombia and it didn't make it—we seized the money, and there were two pilots that were taking that money down. Our reports are that each of them had a family member in Colombia killed because they lost the

money. They were held responsible for it. That's when we started realizing who we were dealing with. We're dealing with top dogs down here by going after the money." *Frontline's* four-part series "The Drug Wars" began airing March 9, 2000.

In the early 1980s, the United States was in a tight-money recession, and every Federal Reserve Board Branch—except one—reported a shortage of cash. San Francisco, New York, Minneapolis, Kansas City, Boston, Chicago—each Federal Reserve Branch showed a deficit. All except Miami, which reported a growing surplus quarter after quarter. It was as if the nation's money supply was draining into Florida.

The smugglers single-handedly kept Florida out of the recession. National economists became aware for the first time of the serious financial impact of drug smuggling. Miami was awash in cash, and that had serious implications for the regional economy.

Florida real estate was booming, in part because smugglers realized buying and selling real estate was an excellent way to cool their hot money. Proceeds from a home or land sale, for example, were clean and bankable. These and other dodges to avoid the bank restrictions created a new profession: the money launderer. In 1986 Congress made the new profession illegal with the Money Laundering Control Act.

By the mid-1980s, a bevy of restrictions were in place. Any cash deposit of more than $10,000 needed a declaration including positive identification of the depositor. While this was required since the 1970 Bank Secrecy Act, it was virtually ignored until 1985, when the Bank of Boston was fined $500,000 for not reporting $1.2 billion in transactions. Wire transfers, new accounts, negotiable instruments like cashier's checks—all came under tighter controls.

After 1985 a smuggler could no longer cool his hot money with a simple bank deposit. Some resorted to "smurfing," where accomplices went from bank to bank making deposits just under the $10,000 reporting threshold. This technique is still used, but only for smaller ventures. Smurfing becomes extremely labor-intensive and expensive when billions are moved around.

Others resorted to bulk smuggling of cash. IRS Agent McDonald recalled stopping a private aircraft bound for Panama from Miami with $5.4 million aboard. A search warrant turned up a ledger indicating that single pilot ferried more than $1 billion in cash to Panama in his career. The logistics are daunting: $1 million in $20 dollar bills weighs 114 pounds. $20 million is more than a ton. "We're talking about people that were getting up to $7 million a day and had to launder it," McDonald told *Frontline*.

In 1992 Congress required that banks report any suspicious financial activity—regardless of amounts or limits—without informing the customer.

And banks were given limited protection from civil lawsuits for complying with the new federal requirement. The provision was expanded in 2002 to include the entire money services industry, including check cashing, money order purchases and the issuance of traveler's checks. Bankers now could rat on suspicious customers behind a veil of secrecy.

In addition to keeping an eye on current activity, federal agents began looking for assets hidden years ago by smugglers. On February 10, 2000, John Varrone, a senior executive with the U.S. Customs Service, testified to Congress:

> *It was the excellent work performed by our Asset Removal Group in South Florida that traced the assets of a convicted marijuana smuggler, who for nearly 15 years, had hidden his assets through a myriad of nominee corporations, business dealings, and off shore bank accounts. Despite his best efforts, the Asset Removal Group was able to trace the profits of his drug trade. Just last year [1999], this convicted drug smuggler forfeited 50 million dollars to Customs, the largest single Customs Service and Treasury Department monetary seizure. The Monroe County [Florida] Sheriff's Office provided substantial assistance to the investigation and, based upon their contributions, last year, Commissioner Kelly shared 25 million dollars of the seized money with that department.*

Contraband continued to flow, and the cash kept coming in. It became increasingly difficult to move the earnings. The only safe place appeared to be under the mattress, and spending it was dangerous too because then the Internal Revenue Service could investigate for nonpayment of taxes.

Prior to 2001, people smuggling millions in cash out of the country in a backpack, briefcase or luggage only violated a customs regulation for failure to report it on a declaration form. Often the cash could not be confiscated. And as law enforcement officials realized, the cash smuggler was inevitably a low-ranking member of the smuggling ring. If jailed, they were easily replaced.

The Bulk Cash Smuggling Act of 2001 was introduced prior to the September Al-Qaeda attacks in New York and Washington. It made cash smuggling a federal felony, punishable by five years in prison. And it allowed the government to seize the cash. After September 11, the proposal was wrapped into the omnibus U.S.A. Patriot Act of 2001 and became law.

During debate on the bill, Representative Marge Roukema (R-NJ) said, "It has been reported that over $30 billion a year is smuggled in, out and through the United States each year by drug dealers, organized crime and

terrorist organizations. This money moves by planes, trains, automobiles, ships and even by mail."

Smuggling money in bulk amounts circumvents all the new regulations. The National Drug Intelligence Center's 2005 "Threat Assessment" shows Florida as the third or fourth highest destination for cash headed out of the country between 2001 and 2003 (depending on the year). Miami and Orlando were popular staging grounds to assemble the money because as top tourist destinations, they are high-cash areas. The addition of a couple billion more there would be less noticeable than, say, in North Dakota.

Economists are trying to get an idea of the magnitude of this phenomenon of mobile underground cash. Miriam Wasserman wrote for the Federal Reserve Bank of Boston's *Regional Review* in the first-quarter edition of 2002:

> *Today, nobody knows for sure how much money is laundered globally. It is difficult to know if money is being counted more than once as it cycles through the system and harder still to know how much goes undetected. Nonetheless, experts believe the amounts are large. The most cited figure is between 2 and 5 percent of global GDP* [Gross Domestic Product]—*or between $600 billion to $1.5 trillion per year. Still, this is an admittedly rough estimate based on extrapolations of the global sales of illegal drugs on the lower bound, and estimates of the size of underground economies on the upper bound.*

Wasserman's low estimate of $600 billion (for illegal drugs only) in global money laundering is vastly higher than Congressman Roukema's estimate of $30 billion in the United States. Roukema's estimate would require laundering $1,000 every second to keep pace in America. Wasserman's estimate would require laundering $20,000 every second globally.

Kenneth Rijock knows how to do it. He laundered hundreds of millions for the cocaine cartels before his arrest and conviction. He told Congress on June 23, 2000, "I was for 10 years a career money launderer for narcotics trafficking organizations who smuggled drugs through Florida and thereafter distributed them throughout the United States and Canada. It was my responsibility to ensure that the proceeds of narcotics crime made it safely through the world banking system and into the tax havens, whose offshore jurisdictions attracted dirty money by combining bank secrecy with a legal obscenity known as corporation secrecy. I was able to operate with virtual invincibility from law enforcement attack due to these laws. The tax havens are the most powerful ally drug traffickers have."

Another ally, Rijock noted, is the fixed habits of law enforcement. "I can tell you from personal experience that narcotics traffickers and their money laundering cohorts exploit law enforcement's seniority system. When all of your experienced senior agents are watching the Redskins game on Sunday, leaving more junior, inexperienced hands on duty during the infinite number of off days and legal holidays, the dope comes in and the money goes out right past the people least qualified to recognize what's happening," he told the House Committee on Government Reform.

Once overseas, life gets easier for the cash smuggler. The money is simply deposited in a foreign bank into the account of a real business or shell corporation, where it disappears into the ebb and flow of currencies. The account holder then can legally transfer the money by wire back to an American bank, and then draw against it at any ATM (automated teller machine). The dirty money is now clean.

Banks are cropping up in the oddest places. For example, the tiny Pacific island of Nauru—all eight square miles of it—is the world's smallest independent republic. The *CIA Factbook 2006* notes, "intensive phosphate mining during the past 90 years—mainly by a UK, Australia, and NZ consortium—has left the central 90% of Nauru a wasteland and threatens limited remaining land."

Furthermore, Nauru is broke. "In anticipation of the exhaustion of Nauru's phosphate deposits, substantial amounts of phosphate income were invested in trust funds to help cushion the transition and provide for Nauru's economic future. As a result of heavy spending from the trust funds, the government faces virtual bankruptcy," the *CIA Factbook* observes.

In the 1990s Nauru "lacked a basic set of anti–money laundering regulations, including the criminalization of money laundering, customer identification and a suspicious transaction reporting system. It had licensed approximately 400 offshore 'banks,' which were prohibited from taking deposits from the public and were poorly supervised. These banks were shell banks with no physical presence. Excessive secrecy prevented the disclosure of the relevant information," according to the 1999–2000 report by the Financial Action Taskforce on Money Laundering of the OECD (Organization of Economic Cooperation and Development).

Wasserman wrote that Nauru "allowed people to set up banks for as little as $25,000 without even setting foot on the island. The nation has been accused of facilitating the laundering of $70 billion in Russian Mafia money through almost 450 banks based there (all registered to the same government post office box)."

Rijock was asked what happens to laundered money once it reaches an offshore bank. "What would happen is, let's take $5 million sitting in a bank

account in Nauru. The next day it goes to Taiwan; two days later, it's in the account of a French mortgage company; three weeks later it ends up in a Panamanian corporation with bearer shares. It ends up being used to obtain a loan in a western European country, totally kosher," he told the committee.

"And if money laundering institutions which are very well organized by now know that, we're not talking about people from Miami with gold around their neck, sir. We're talking about people with Ivy League law and MBA degrees who sit in some of the biggest cities in the United States and form overseas companies without so much as picking up a telephone. We're talking about organizations that are so sophisticated that they almost defy description. And they've been in place now for 20 years, they're getting better and better. And that's why more money is moving," said Rijock.

At a May 15, 1997 hearing before the House Committee on Banking and Financial Services, Edward Federico of the IRS's Criminal Investigation Division said, "There's no doubt that legitimate businesses are being utilized. The money itself has been cleaned up and is just part of the money flow."

A lot has happened since Nauru opened its doors to the world's money launderers. In 2000, the Financial Action Task Force of the OECD published a list of fifteen countries with wide-open banking laws. The next year it added eight more. They were called "non-cooperative countries and territories." And the task force recommended a series of tough measures to force the twenty-three countries and territories to adopt anti–money laundering initiatives (for example, making money laundering a crime).

The effort is considered successful; in 2006, only one country remains on the list—the rogue state of Myanmar (ex-Burma). Nauru was taken off the list in 2005 after closing four hundred banks and passing appropriate legislation.

So the money launderers moved on to a new scam: the Black Market Peso Exchange (BMPE). The smugglers of Colombia and Mexico have a problem. Their vast incomes are in American dollars, but they need pesos to buy gasoline and racehorses and to bribe judges. Dollars won't pay the payroll, buy the coca or cater their meals. This problem applies to all high-dollar smugglers, not just the dopers.

Instead of hauling around dollars by the ton, they turned to Latin America's well-established system of currency exchange brokers. The BMPE started in the 1960s as a response to Central and South American nations' complicated system of currency restrictions. A lively black market in currency exchange was developed. By tapping into it, smugglers don't need to move their money physically across borders.

The deal works like this. Sam the smuggler in Bogotá has $3 million in Miami and wants pesos in Colombia. A bank would give him, for example, 200 pesos per dollar, if he could get the dollars to Colombia.

Instead Sam goes to the local Black Market Peso Exchange and cuts a deal with Moe the money-changer. Sam gets 160 pesos to the dollar from Moe's Columbian bank account for his $3 million. Moe gets the $3 million in Miami.

Sam calls Miami and says, "Gather up the $3 million and go to the luggage store." Three million in $20s will fill six full-size suitcases. Moe calls his man in Miami and says, "Six suitcases are waiting for you at the luggage store." Moe's guys pick up the dollars and start smurfing them into bank accounts.

Moe's inventory of pesos is down (Sam has them now), and his dollar supply is up. Moe now looks for somebody needing dollars. Maybe it's auto-store owner Carlos in Bogotá, who needs dollars to buy a shipment of carburetors from Detroit. Moe the money-changer can offer a good exchange rate, say 185 pesos to the dollar, because Moe got the dollars cheap. Carlos writes Moe a check in pesos, drawn on his legitimate bank account in Bogotá. Moe deposits the smurfed dollars in Carlos's account in Miami to buy the carburetors and puts Carlos's pesos in his Colombian account. Now Moe's peso supply is replenished in Colombia and his dollar inventory is down in Miami. Meanwhile he's made money on the difference, doing the buy-low-sell-high dance.

Carlos does not receive the market rate, but has an incentive to go to the Black Market Peso Exchange. If Carlos went to his Bogotá bank to change the money, the bank would demand identification, want to know why Carlos needed dollars, did he have the appropriate import license and will he be paying the customs and excise duties on the carburetors? The license is time-consuming to obtain, the customs and taxes are expensive and it is all a bother. So it's easier, faster and cheaper for Carlos to visit Moe.

Everybody's happy. Sam has pesos to run his cocaine cartel; Carlos has dollars to buy his carburetors; and Moe lives on the wide split, accumulating profits on both deals. That's the simple version. It is propelled by Sam's desire to dump his dollars, even at a steep loss.

It gets more complicated. What if Sam owns Carlos's auto parts store? Or what if Moe wants to cut deals with multinational corporations, buying pesos with dollars or vice versa? Both circumstances are appropriate because the cocaine cartels diversified over the decades into scores of legitimate businesses, and multinational corporations are always looking for the best currency exchange rates.

The real world numbers show how profitable the BMPE can be. The money exchangers demand a 30 percent commission from the smugglers. They can pass a fraction of that savings to their dollar customers, making them quite attractive to very large businesses that are always looking to shave a percentage on currency transactions.

But should multinational corporations benefit from money laundered by the drug trade? McDonald says one American firm decided to abstain. "General Electric took very aggressive steps to ward off the black market money coming into its company from sales to Colombia. And I believe the figure is about 25 percent of sales that they lost. Now, I assure you that 25 percent fewer refrigerators or washers and dryers were not bought in Colombia, but they just went to other businesses," he told *Frontline.* Other corporations took note of the drop in sales and declined to follow GE's lead.

Other multinationals haven't been so altruistic. At an October 22, 1997 hearing before the House Banking and Financial Services Committee's General Oversight and Investigations Subcommittee, Chairman Spencer Bachus (R-AL) opened the proceedings by saying,

> *This form of money laundering is particularly harmful for a number of reasons. It provides a very safe and quick method for the drug cartels to obtain their illegal profits. With the use of the peso broker as a middleman, the cartels can obtain their profits almost immediately.*
>
> *In economic terms, peso brokering permits the cartels to launder their money by piggybacking on world trade. From this perspective, however, black market peso brokering threatens the legitimacy of the world economy. In essence, black market peso brokering results in Fortune 500 U.S. companies being paid in drug dollars. We will hear today the names of certain U.S. companies that have had their exports paid with narco-dollars. This is not to indict these U.S. companies for selling their goods to legitimate businesses in Colombia and other countries. However, the reality is that when peso brokers are used to pay U.S. companies for their exports to Colombia and other countries, these U.S. companies, knowingly or not, are facilitating money laundering and providing an easy mechanism for the drug cartels to reap their profits.*

Bachus then introduced the first witness, a woman named "Jane Doe." She sat behind a screen, flanked by two beefy law enforcement agents. She then proceeded to name names. "As a money broker, I arranged payments to many large U.S. and international companies on behalf of Colombian importers. Some of these companies included Sony, Procter & Gamble, John Deere, Whirlpool, Ford, Kenworth, Johnny Walker, Swatch, Chorrera, Orleander Group, Orotex, Italian Telas, Commercial Colve, Allen Bradley, Jacobsen's, J&B Importers, U.S. Gear Corp, Merrill Lynch, Cotextil, Industrias Ossa, Taiwan Hodaka Industrial Company, Seattle Bike Supply, Troy Lee Design, T. Gears, Dentsply, Reebok, Amcol International, Inc., and Midatlantic Purveyors. These companies were paid with U.S. currency

generated by narcotics trafficking. They may not have been aware of the source of this money. However, they accepted payments from me without ever questioning who I was or the source of the money."

On October 30, 2002, the European Union filed lawsuit against RJR Nabisco (and associated subsidiaries) in U.S. District Court alleging:

> *The RJR defendants have, at the highest corporate level, determined that it will be a part of their operating business plan to sell cigarettes to and through criminal organizations and to accept criminal proceeds in payment for cigarettes by secret and surreptitious means, which under United States law constitutes money laundering. The officers and directors of the RJR defendants facilitated this overarching money-laundering scheme by restructuring the corporate structure of the RJR defendants, for example, by establishing subsidiaries in locations known for bank secrecy such as Switzerland to direct and implement their money-laundering schemes and to avoid detection by U.S. and European law enforcement.*
>
> *This overarching scheme to establish a corporate structure and business plan to sell cigarettes to criminals and to launder criminal proceeds was implemented through many subsidiary schemes across the European Community.*

The suit ended in the lap of the U.S. Supreme Court, which instructed the appeals court to reconsider its ruling against the European Union.

While legislation has been introduced in Congress since 1998 to provide sanctions against companies playing in the Black Market Peso Exchange, nothing has passed since the bulk cash smuggling bill was rolled into the Patriot Act of 2001.

Convicted money launderer Rijock wonders why: "When I used to launder cash in the Caribbean, and I would sit out there on the porch in St. Martin and drink a cup of coffee and watch the sun come up, I wondered, one of these days, am I ever going to see an American aircraft carrier out there, and are the Marines going to come ashore, arrest all the bankers, close down the banks, take the records, take them to Miami, and charge all those people in Federal court with money laundering? Well, that's never happened. Because nobody's decided that it's important enough."

In the 1980s, the majority of paper currency in the United States was contaminated with cocaine powder. By the turn of the century, multinational corporations were tainted with smugglers' profits.

THE FUTURE OF SMUGGLING

FACT

Smuggling concerns more than "people and things." We've seen how individuals are willing to risk imprisonment or even death to move contraband. The list of smuggled goods is almost endless, and even the government doesn't have a tally of how many things are forbidden. As one old customs department hand explained it, "We enforce 600 laws for 60 different Federal agencies."

The CITES list alone holds more than 33,000 species. Counterfeit goods—bogus NFL T-shirts to Gucci suitcases—add thousands more items. Pirated software and music is another "bottomless" category. You can be sure the uniformed customs and border protection official you won't make eye contact with when you pass through the international airport doesn't know the total number either. Contraband is like love or porno—you know it when you see it.

But there is contraband beyond "people and things." It is the most powerful contraband of all: ideas. Florida played a role there too, a role it continues to play. We need only to look at—once again—our neighbor to the south.

The fiery poetry of José Martí raised considerable sums in Florida through the cigar-rollers' self-imposed 10 percent tax on wages. It bought the arms Napoleon Broward smuggled south. The continued resistance of the insurrectos would have collapsed without either the arms or the money. The stirring words of Martí were the most potent export of all. When the Spanish-American War started in 1898, support for the Spanish colonial government was vanishingly small in both Cuba and the United States.

A similar, although less well-documented, effort began in the late 1950s in support of another revolutionary firebrand against outside oppression on the island. Cuba had become a colony again, this time ruled by American organized crime and multinational corporations.

The government of Fidel Castro today does not recognize the clandestine support it enjoyed as rebels in the hills from a new generation of filibusters in the United States. In neither case can the smugglers claim to be the deciding factor. But in both cases, radical changes in the Cuban political system were presaged by smugglers moving guns, cash and ideas across the Florida straits.

The saga goes on. Anti-Castro Cubans are now engaged in the same exercise. Guns, money and ideas were smuggled south in the last third of the twentieth century to try and break Castro's Marxist-Leninist grip on the country. Anti-Castro Cubans hope "the third time is the charm."

Arms smuggling from Florida remains robust. Guerilla groups from all over the hemisphere (and beyond) are happy to buy Florida's guns and smuggle them home. Filibustering is alive and well.

Of all the impacts of smuggling on Florida, none is more important than the economic influence. Big-money smuggling came to Florida three times in the twentieth century—rum, marijuana and cocaine. In all three, the prosperity was shared. First and foremost, the banks benefited.

Banks work a bit like the Black Market Peso Exchange but in reverse. You deposit money in the bank and receive a small amount of interest. Banks lend "your" money to homebuyers, expanding businesses and other worthies at a higher rate of interest. Banking profits largely come from the difference between the two positive interest rates. The peso exchange works like this but in the opposite direction, with negative interest. An economist will argue the BMPE is a deflationary mechanism, while banks are regulated by the prime rate to control their inevitable inflationary mechanism.

Big-time smugglers often come from unsophisticated backgrounds. Banks are an obvious place to put their profits. This allows Florida banks to lend more money. And that is good for Florida's primary industry: selling swampland to Yankees. Florida's land booms coincide with Florida's smuggling booms. Even when the rest of the country was in a recession during the early 1980s, pot haulers and their friends kept Florida afloat in cash. Which was good for the banks, good for real estate, good for car dealers, grocers, just about anybody in business—especially for anybody wanting a loan to buy a home.

Until 1985, Miami's banks still weren't checking identification and billions more moved into the banks. The dramatic—some say overreaching—architecture of Miami was one consequence.

Another was the contamination of the U.S. money supply with cocaine. In 1996 three men gathered batches of one-dollar bills in several cities across the country. They reported in the *Journal of Toxicology* that "Cocaine was present in 79% of the currency samples analyzed."

As the Miami money-counting machines sorted the smugglers' gains, the powder-fine grains of cocaine contaminated the machines, which spread it everywhere. Imagine putting money in a counter and seeing a puff of cocaine dust appear.

One consequence was political embarrassment when reporters swapped out bills with major political figures on Capitol Hill and had the cash checked. Yup, most of the senators and reps were holding cocaine-tainted money. The more serious question went unasked: how tainted were the congressmen?

It is difficult to believe a $10 billion-plus per year industry didn't try to exert political leverage with campaign contributions in the United States. The cartels certainly were funneling money into Colombian politics. But no major scandal erupted in the United States. So the impact of cocaine money on U.S. politics remains conjectural.

It is interesting to note a bulk cash transportation bill was introduced several years before 9/11/01 but didn't pass until the Patriot Act was approved. A bill on the Black Market Peso Exchange—used by smugglers and many major U.S. multinational corporations—remains stalled in Congress.

The future of smuggling, as always, is in a state of flux. As we move into an electronic future, with microchips embedded in cargo containers and even individual goods, it might appear the days of load-up-and-go smuggling are finished. As we saw in Florida, it was possible to defeat two richly funded, ruthlessly staffed and highly disciplined smuggling cartels. Their hierarchical structure actually contributed to their downfall, and today's smugglers—always adaptable—have learned an important lesson.

The "key man" is no longer necessary. Today's smugglers enjoy all the tools of globalization: outsourcing, networking, teamwork and flexibility. While supply and demand remain the two extremes of any contraband endeavor, the smugglers in the middle are diversifying in both products and tactics. The men who smuggled Cubans in the late 1990s also had smuggled cocaine; ditto for the gangs who used cruise ships. Brokers and agents are replacing kingpins. Cooperation for mutual profit is now the password to success.

That cooperation is not limited to fellow smugglers. Terrorists and other political entities are showing up in the smuggling story with increasing frequency. In a world with an apparently limitless appetite for contraband, smugglers and their allies are growing in number and power. With its long and colorful history, Florida will not be exempt from the licit and illicit influences of smuggling. Miami has joined Shanghai and Tangiers in the pantheon of smuggler havens.

Will the nature of contraband change? In Florida we began with smuggling humans, and it is still going on. Thanks to America's gun lobby, assault weapons are available to anyone. Armaments are easy to purchase and dispatch to other countries, so arms smuggling will continue to be a secure niche. Anything legal in one place and illegal in another is an open invitation to smuggling.

While the end of Prohibition terminated big-time liquor smuggling, it will remain a hobbyist's pastime. There's a bottle of Havana Club rum in my kitchen, courtesy of my last visit abroad (and my impulsive desire to evade authority). Rare and expensive stuff will still be smuggled but primarily for individual cachet.

The customs and border protection staff will continue to enforce the constantly changing "600 laws for 60 agencies"—that endless list including human heads, bird eggs, Saudi coins, Incan textiles, weird reptiles, banned carpets and caviar. Miami doesn't need a zoo. It has an airport.

As long as there is a demand for contraband, it will be supplied. If prices are high enough, supplies of illicit goods will continue to attract organizations willing to invest in the means of production and transportation, plus the necessary "plata o plomo."

The illegal drug smuggling industry is in transition, because an increasing number of drugs are illegal. Heroin, cocaine, methamphetamines and marijuana are already billion-dollar businesses. Each new generation seizes on a new illegal drug of choice. Medicinal drugs are starting to enter the smuggling market, thanks to recent changes in the American Medicare program. Florida's drug smugglers are not going away.

One constant remains—cash. Smuggling is a business. No matter what the cargo, the end result is cash. It is the Achilles heel of all smugglers. As money laundering laws tightened, the smugglers adapted with increasing sophistication. Banks opened for business on islands nobody could find on a map. And when they were closed, an even slicker method was used that didn't move cash beyond national borders.

Kenneth Rijock, the convicted money launderer, is correct: very talented and sophisticated people are working on money laundering. The stakes are billions of dollars. The globalization of international finance has created innumerable loopholes and havens for hot money. And as the American war on terrorism shows, the old tactic of "follow the money" doesn't work anymore because the trail is impenetrable.

Smugglers realize cash is their weakness. They must sell in cash, but what to do with it? The future of big-time smuggling lies with those anonymous, talented and sophisticated people in the towers of the world's money centers who are working ingeniously to keep the illicit proceeds flowing.

The future of individual smuggling will remain rosy, subject only to the occasional arrest by sharp-eyed CBP officials. Smuggling by organizations is increasingly vulnerable to penetration and interception by many different intelligence agencies.

The link between terrorism and smuggling involves the full national intelligence apparatus—human spies, electronic eavesdropping, mail opening, traffic analysis, cryptography, etc. All smuggling organizations are now in an "intelligence battle" with the authorities, similar in many respects to the cold war. But it is a battle between entrenched bureaucracies and agile, increasingly decentralized smugglers using a host of modern electronic and cybernetic tools. With the current American focus on terrorism and immigration, fewer resources are available to attack smuggling.

The increasing wisdom of machines will be the cutting edge of interdiction, the ultimate snitch that breaks codes, discerns communication patterns, traces cash flows and perhaps even produces an analysis of individual human behavioral patterns.

In South America today, potential kidnap victims are implanting themselves with Global Positioning System chips readable by satellite. The increasing "microchipping" of passports, cargoes and individuals will be coupled with the inevitable introduction of a universal national identification card to create an electronic mesh readable by networked machines. But smugglers will adapt. Especially if they can get inside information from headquarters.

Years ago I took a reporter's sabbatical to pursue a graduate degree in Washington, D.C. I'd stayed too long at the library and the buses had stopped running. I walked over to Massachusetts Avenue on a bitter January night and stuck out my thumb, hoping for a ride downtown. After a while, a battered pickup truck stopped and a young man gestured me inside. We rode in silence for a while. He asked if I was a student, where, for what degree. We chatted. He was from Texas, single.

I popped the usual D.C. question: "What do you do?" He took a drag on his Marlboro and said, "I'm in the coast guard."

"Good for you," I said. "I'm a sailor. I like you guys. You working in some headquarters?"

"Yeah, I'm in the drug interdiction center."

"Wow. You know, I'm from Florida, and there's a lot of people who'd like to know what you know."

"Yeah." He smiled.

"I mean, if you were careful, you could make a lot of money."

"Yeah, if I was careful." Then it was my stop, Dupont Circle.

"Thanks for the lift, coasty," I said as I opened the door. Then he gestured at me.

"If I was careful, I'd drive a ratty old truck like this, wouldn't I?" I smiled and saluted. He drove off into the night.

FICTION

With weak knees, Juan Ortiz stepped off the suborbital liner into the transport tube. All the passengers were weak-kneed. The high-G, zero-G, high-G flight from Hong Kong to Miami was fast but physically punishing. And it produced a lot of stress pheromones. He was relying on that to pass the first bank of sniffers.

At the end of the tube, he waited for an arrow to indicate which entrance to the maze he would use. The maze shifted daily, so left-or-right indicated nothing. Everybody on the flight was under scrutiny, and some search was inevitable. Left, the arrow indicated.

The plain hallway concealed any number of scanners, sniffers and other remote-sensing devices. His strength was coming back and he picked up his pace. The first desk was always the same.

"Passport, please," said the official. Ortiz handed it over. Passports were tattletales now. The GPS recorder tracked its movements. An active micromemory chip remembered its communication with other devices. The ancient barcode still communicated its unique persona. This was the first test. "Thank you, Mr. Ortiz," the official said. "Have a pleasant stay in Miami. Please take the left-hand hallway."

Left, then another desk but the official waved him on, left again. Ortiz realized he was being shunted to the periphery of the maze, into the grey zone, where national laws didn't apply and international law didn't exist. He'd prefer to be in the middle of the maze, but had no choice. A short walk led to another official, who glanced up from his terminal.

"Mr. Ortiz," he said. "Could I ask a few questions?" So far, this was normal for the suborbital routine. This was to be expected. "Anything to declare?"

Juan produced his declaration form, listing a bottle of excellent Japanese whisky, two non-pornographic carvings and a new silk suit. All totaled, just under the dollar limit for customs duties.

The official looked at his screen. Seconds ticked by. Juan defocused. The official could take as long as he liked.

"Mr. Ortiz, you declared two carvings. May I see them?" Juan looked up, and behold! His single piece of luggage was in a corner of the maze, just ahead. "May I?" "Please."

Juan kneeled down and flipped the latch. The black nylon lid rose. The official knelt down to rummage through the bag. Juan felt a wave of caution. This kneeling uniform was not good news. The official produced a wand and touched the carvings.

Juan rose, and after a moment, the official rose too. "Everything seems to be in order, sir. I'm a whisky fan too, especially Suntory Islay. Mazeltov."

He repacked Juan's bag and sent him right. A very good omen. After a long walk with his bag, Juan emerged into a brightly lit and open area. He stopped for a moment to orient himself, saw "Ortiz" on a hand-held sign, and walked through a turnstile to emerge into "the public."

In his testicle was an illegal implant. Six fertilized DNA capsules, cooking and expanding clones. He had two hours at most to appear at the appointed clinic only a cab ride away.

SELECTED BIBLIOGRAPHY

Alduino, Frank. "The Damnedest Town This Side of Hell: Tampa 1920–1929." *Sunland Tribune: The Journal of the Tampa Historical Society* 16 (November 1990): 13–18.

Asbury, Herbert. *The Great Illusion: An Informal History of Prohibition.* New York: Doubleday, 1950.

Brown, Loren "Totch." *A Life in the Everglades.* Gainesville: University of Florida Press, 1993.

Buker, George. *Swamp Sailors in the Second Seminole War.* Gainesville: University Press of Florida, 1997.

Carse, Robert. *Blockade: The Civil War at Sea.* New York: Rinehart & Company, 1958.

Carter, James III. "Florida and Rumrunning During National Prohibition." *Florida Historical Quarterly* 48 (July 1969): 48–57.

Convention on International Trade in Endangered Species of Wild Fauna and Flora. http://www.cites.org/

Covington, James. *The Seminoles of Florida.* Gainesville: University Press of Florida, 1993.

CubanBest Cigars. *CubanBest Cigar Newsletter* (April 2003). http://www.cubanbest.com/cubancigarnewsletter5.htm

Drug Enforcement Administration. "National Drug Threat Assessment 2006." http://www.dea.gov/concern/18862/index.htm

Financial Action Task Force. "Annual Review of Non-Cooperating Countries and Territories, 2005–2006." 23 June 2006. http://www.fatf-gafi.org/dataoecd/0/0/37029619.pdf

Frontline. "The Drug Wars." 4 part series. Originally aired on PBS (October 2000). http://www.pbs.org/wgbh/pages/frontline/shows/drugs/

Fuson, Robert. *Juan Ponce de León and the Spanish Discovery of Puerto Rico and Florida.* Blacksburg, VA: McDonald & Woodward Publishing Co., 2000.

Green, Ben. *Finest Kind: A Celebration of a Florida Fishing Village.* Macon, GA: Mercer University Press, 1985.

Gugliotta, Guy, and Jeff Leen. *Kings of Cocaine: An Astonishing True Story of Murder, Money and Corruption.* New York: Harper & Row, 1989.

Herrera y Tordesillas, Antonio de. *Historical general de los hechos de los castellanos en las isles, y tierra-firme de el Mar Occeano* [General History of the Castilians in the Island and Mainland of the Ocean]. 10 vols. Asunción, Paraguay: Editorial Guarania, 1945.

House Committee on Government Reform. "Combating Money Laundering." June 23, 2000. http://www.ciponline.org/financialflows/combatmoney.pdf

"HR 2920 Bulk Cash Smuggling Act of 2001." The Avalon Project at Yale Law School. http://www.yale.edu/lawweb/avalon/sept_11/hr2920_ih.htm

Kobler, John. *Ardent Spirits: The Rise and Fall of Prohibition.* New York: Putnam, 1973.

Martire, Pietro d'Anghiera. "Impressum Hispali: per Jacobum Corumberger Aleanaum." April 1511. John Work Garrett Library, Johns Hopkins University.

Mowry, David P. "Listening to the Rumrunners." National Security Agency / Central Security Service. http://www.nsa.gov/publications/publi00018.cfm

Mundt, Michael. "'Deplorable Conditions': Tampa's Crisis of Law and Order in the Roaring Twenties." *Sunland Tribune: The Journal of the Tampa Historical Society* 22 (November 1996): 69–74.

Nova. "The Great Wildlife Heist." Originally aired on PBS (March 11, 1997). http://www.pbs.org/wgbh/nova/transcripts/2111zwild.html

Pizzo, Anthony P. *Tampa Town: 1824–1886.* Miami: Hurricane House Publishers, 1969.

Reynolds, Julia, with William Kistner and Omar Lavieri. "Jean Bernard Lasnaud: South Florida's Elusive Arms Baron." *PBS Frontline/World.* From the episode "The Gunrunners," aired May 2002. Transcript available at http://www.pbs.org/frontlineworld/stories/sierraleone/lasnaud.html.

Rothchild, John. "The Day Drugs Came to Seinhatchee, Florida." *Harper's Monthly,* January 1983.

———. *Up For Grabs: A Trip Through Time and Space in the Sunshine State.* New York: Viking, 1985.

Shofner, Jerrell. "Smuggling Along the Gulf Coast of Florida During Reconstruction." *Sunland Tribune: The Journal of the Tampa Historical Society* 5 (November 1979): 14–18.

Sparke, John, Jr. "The Voyage Made by M. John Hawkins, Esq." *Voyages.* Edited by Richard Hakluyt (1589). Quoted in Charles Bennett, *Laudonniere and Fort Caroline: History and Documents* (Gainesville: University of Florida Press, 1964).

Trask, David. *The War with Spain in 1898.* New York: Macmillan, 1981.

United States Department of the Treasury. "Office of Inspector General semiannual report." October 1, 1994—March 31, 1995. http://www.usdoj.gov/oig/semiannual/9603/sa961p1.htm

Viele, John. *The Florida Keys: True Stories of the Perilous Straits.* Vol. 2. Sarasota, FL: Pineapple Press, 1999.

Wasserman, Miriam. "Dirty Money." *Regional Review* (Federal Reserve Bank of Boston) 12 (2002). http://www.bos.frb.org/economic/nerr/rr2002/q1/dirty.htm

INDEX